POSTCARD HISTORY SERIES

Winter Park

IN VINTAGE POSTCARDS

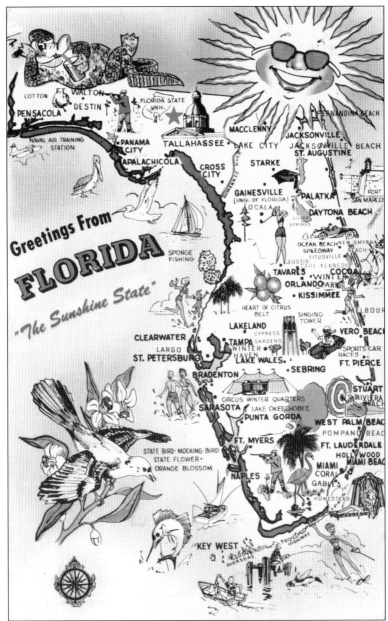

This vintage postcard helps to locate Winter Park on the Florida map. You can just see it peeking out from behind Orlando (though the "P" is hidden) and tucked under Cocoa in the east-central section of the state. This pre–theme park card promotes the outdoor activities people have always enjoyed doing in Florida: swimming, sailing, hunting, fishing, bird-watching, sunbathing, and waterskiing. If you look closely, just north and east of Winter Park, you can see Cape Canaveral identified as Cape Kennedy, which it was called for a short time after the assassination of Pres. John F. Kennedy. NASA's installation there is now called the John F. Kennedy Space Center at Cape Canaveral. The sun wearing sunglasses and the alligator up near Pensacola sipping his cold drink are two of the more enjoyable features of this vintage "Greetings From Florida" card.

POSTCARD HISTORY SERIES

Winter Park

IN VINTAGE POSTCARDS

Robin Chapman

ARCADIA

Published by Arcadia Publishing
Charleston SC, Chicago IL, Portsmouth NH, San Francisco CA

Printed in the United States of America

Library of Congress Catalog Card Number: 2005923840

For all general information contact Arcadia Publishing at:
Telephone 843-853-2070
Fax 843-853-0044
E-mail sales@arcadiapublishing.com
For customer service and orders:
Toll-Free 1-888-313-2665

Visit us on the Internet at www.arcadiapublishing.com

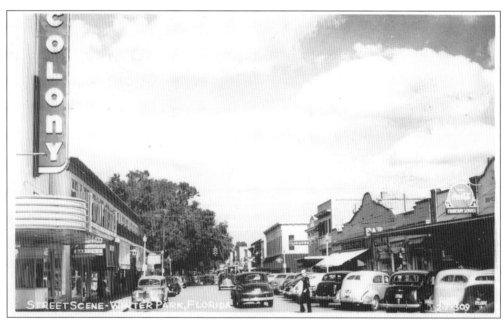

Something about Winter Park's Park Avenue seems to say, "Main Street U.S.A." It is as true today as it was when this World War II–era postcard was produced. The Colony Theater was a popular landmark on Park Avenue then, back when movies were usually shown in main street theaters. The most interesting thing about this card is the young sailor, looking over at the camera as he jaywalks across Park, wearing his cap at a jaunty angle. Perhaps he was heading to the Colony for an early date at the movies.

Contents

ACKNOWLEDGMENTS

All of the postcards used in this book are from the collection of Mr. Rick Frazee, unless otherwise indicated. Most of the postcard messages I've quoted are also from his collection, though a few come from the files of the Winter Park Public Library and from cards in my own tiny collection. My great thanks go to the following people: Gertrude Laframboise, Department of College Archives and Special Collections, Olin Library, Rollins College; the Orange County Regional History Center; the Florida State Archives; Diana Zimmerman of the Winter Park Public Library; and Peggy Strong, Carol Card, Wanda Salerno, and Bud Sowers for sharing with me their memories. I am aware that a book similar to this one is being researched about West Winter Park, and because of that I have not included the story of West Winter Park in this book. The sad legacy of segregation is that vintage postcards and photographs of West Winter Park are scarce. Those that are presently being catalogued will, I hope, be used in the upcoming book. Finally, this book is dedicated to:

Mr. Rick Frazee, Mr. Dean Padgett,
and
the Winter Park Public Library,
for collecting and conserving our history.

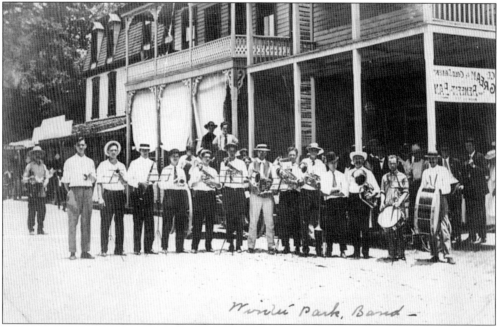

At the turn of the 20th century, Winter Park had two brass bands. The one photographed for this postcard may have just played for a Fourth of July event, since the shirtsleeves on band members suggest the steamy summer season. The members are, from left to right, Walter Schultz, Arthur Schultz, Raymond Ward, Gus Moreman, Ray Trovillion, Joe Ahik, Harley Ward, Ed Favor, Harold Fly, Mr. Searcy, Harry R. Newell, Leland Chubb, and Thomas Henkel. (Courtesy of the Winter Park Public Library.)

INTRODUCTION

Winter Park was unique from the beginning. It didn't start out as a stockade in the Seminole Indian Wars, as did many Florida cities—cities such as Fort Lauderdale, Fort Pierce, and Fort Myers, for example. Nor did it grow as a suburb. Orlando, the nearest larger city, is four miles to Winter Park's south, but when Winter Park was founded in 1881, Orlando wasn't big enough to have anything quite so fancy as a suburb. Winter Park is the first city founded in Central Florida for the sole purpose of catering to visitors. It was created, in the language of today, to be a "destination." It is also Central Florida's first planned city, something the state would see a lot of in the years to come but something rare in its early history.

The state of Florida didn't have many settlers, much less cities, until the late 19th century. It was Spanish territory until 1821, and though it became a state in 1845, it was even then not a friendly place for pioneers. American Indians from many tribes that had been driven out of states in the northeastern United States drifted down to Florida and lived together in the East Coast's last frontier. They were not happy to see American settlers and did what they could to fight them off. The defeat of the American Indians in the Seminole Indian Wars—which ended just before the American Civil War—opened up the state to settlement. For better or for worse, Florida development was underway.

The Industrial Revolution of the 1880s brought steamships to Florida's ports and railroad lines to her interior. Astonished visitors who traveled the St. Johns River[1] in comfortable steam launches from Sanford inland were mesmerized by the exotic birds, the abundance of alligators, the curious manatees, the rich subtropical forests, and the absolutely wonderful winter climate. It is interesting that Sir Arthur Conan Doyle—who was fascinated by the American continent—published his book *The Lost World* in 1912. In the previous three decades, visitors had been discovering their own lost world in Florida.

In 1880 and 1881 the South Florida Railroad was completed between Sanford and Orlando and then finished through to Tampa. That same year, Illinois businessman Loring Chase came to Central Florida for his health. He was suffering from what they used to call "catarrh"— an inflammation of the mucus membranes otherwise known as a cold—and from bronchitis. Living as he had been in Chicago, where the air was increasingly polluted with factory smoke and coal dust, and where the temperature in February rarely reached above freezing, it is no wonder that he had a runny nose and a cough. It is also no wonder that his cold and bronchitis cleared up quickly in the warm winter sunshine of Florida, where industrial smoke was as rare in 1881 as a good hotel.

Loring Chase, his membranes all back to normal, took a buggy ride around the spring-fed lakes just north of Orlando and had a brainstorm: why not develop a resort here? He found several partners to join him in the scheme: Oliver Chapman, of Canton, Massachusetts, the son of one of the founders of the Union Pacific Railroad; F. V. Knowles of Worcester, Massachusetts; and Col. Franklin Fairbanks of St. Johnsbury, Vermont. All of them had plenty of experience with snowy winters. Together, they bought about 600 acres to start and in the next few years acquired 400 more acres. They surveyed and plotted the town, giving it the name that well suited their project: Winter Park. Though there were no written building codes at first, an early marketing brochure states, "The proprietors were emphatic in their restrictions as to the style of buildings that should go up on the lots they sold: and the result is that Winter Park has a collection of as pretty cottages and public buildings as can be found in the entire State (sic)."[2] It was quite a while before the streets were paved, but the developers wanted to make sure the buildings looked good.

They were a step ahead of the man who would become Florida's biggest builder of resorts: Henry Flagler. Flagler was John D. Rockefeller's partner in Standard Oil. His wife had bronchitis, and Flagler came to Florida with her for her health in the winter of 1876–1877. They stayed in Jacksonville and St. Augustine, but Flagler found both towns primitive, and he was not impressed by them. It wasn't until the winter of 1884–1885, after his wife's death, that Flagler bought the land in St. Augustine that would become his first resort, the Ponce de Leon Hotel. Flagler was just three years behind the builders of Winter Park. If it is true that great minds think alike, developers Chase and Chapman blazed the trail in Winter Park that was soon paved, streamlined, and landscaped by the great Henry Flagler in Palm Beach, Miami Beach, and the Florida Keys.

Legend has it that Winter Park had been a winter retreat for Osceola, one of the Seminole leaders who made life so tough for Florida's pioneers. Osceola was captured in 1837 and, through newspaper interviews and several portraits painted by well-known artists, became quite a celebrity in prison before his death from malaria. Early residents said there had been an American Indian trail along Winter Park's central lake and insisted that Osceola, his warriors, and their families often spent their winters on the lake's eastern shore. Whether it was true or not, the lake was named after him, and in the early 20th century residents of Winter Park held an annual "Osceola Day" in his honor.

Northerners Chase, Chapman, and their partners certainly didn't discourage the legend. It is just the kind of exotic backdrop they wanted for this picturesque piece of home they were building in Florida. In spite of the fact that it was surrounded by alligators, citrus groves, and tales of marauding American Indians, Winter Park was really designed to be just like home— but with much better weather.

One

SETTLING IN

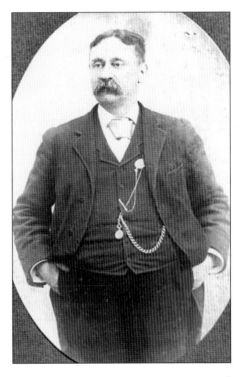

This gentleman, with the wide tie and the walrus moustache, is the man who founded Winter Park. Loring A. Chase was a Union Army veteran with a career that included work as a real-estate broker. He saw that Florida was ripe for development, and he built a resort so that others suffering from the same ailments that drove him south might find a "winter park." He lived to see the little town prosper and died in 1906 at the age of 67. (Courtesy of Rollins College.)

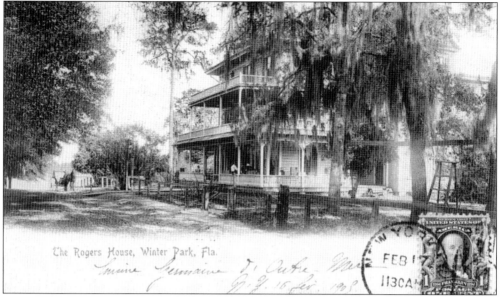

The Rogers House, Winter Park, Fla.

After the train depot went up, the second building that rose in Winter Park was Rogers House Inn, which opened April 8, 1881. The city's investors found Mr. and Mrs. A. E. Rogers camping near town and offered them a lakeside lot, provided they build an inn there. Luckily, Mrs. Rogers was a great cook and the inn was a hit. Still, for this picture postcard, Mr. Rogers forgot to put away his ladder.

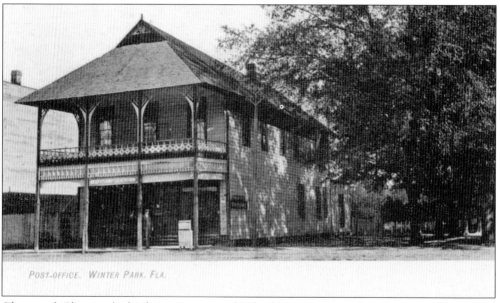

POST-OFFICE. WINTER PARK. FLA.

Chase and Chapman's third structure was this building that served as the post office, town hall, and Ergood's Dry Goods store. It was also a local hangout, as the newspaper reported in 1892: "Postmaster Thayer requests the crowd that usually assembles at the post-office every Sunday evening to please keep quiet during the distribution of the mails. The building is small and the noise and glib which this crowd generally keeps up is simply disgusting and should be stopped."[1]

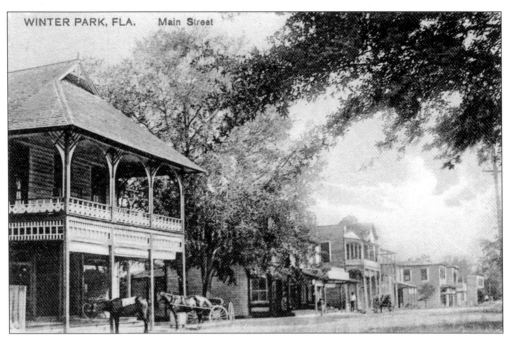

By the time this postcard was mailed in 1900, Ergood's Dry Goods had some company on Park Avenue, though the city remained a small town. As late as 1905, the Travelers Insurance Company asked Winter Park to protect it from damage claims due to hogs running at large on city streets. The city looked into it but said until the human population grew, hogs could continue to roam.

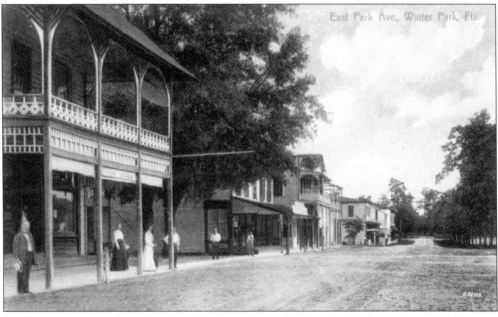

East Park Ave., Winter Park, Fla.

Looking south on Park Avenue just a few years later, the view hasn't changed much. The street is identified as "East Park Ave.," which it was called for many years. There was supposed to be a West Park directly opposite, on the park's other side, that mirrored East Park, but it was never completed. One block of it remains between New England Avenue and Welborne.

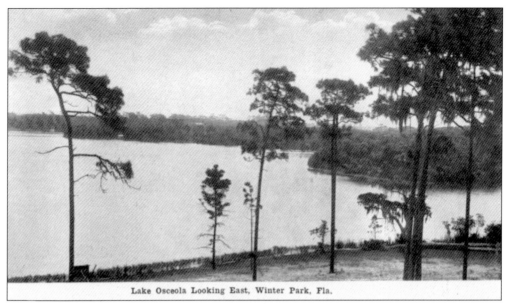

Lake Osceola Looking East, Winter Park, Fla.

Lake Osceola lies just two blocks east of Park Avenue, and though in the 21st century it is ringed with homes, this vintage card shows the lake at a time when—other than a few old pine trees—distant orange groves are the only things in sight. The founders initially planted 1,000 orange trees along the Boulevard (now Morse Boulevard), which they bought from a local grower for 50 cents each.[2]

MOSSY OAK TREE, WINTER PARK, FLA.

E. C. KROPP CO., MILWAUKEE.

Developers Chase and Chapman met every train that stopped in Winter Park and toured visitors around the town site in a horse and buggy. It could be slow going on Winter Park's primitive roads. This vintage card was produced around the turn of the 20th century, when the non-picture side of the card was used for the address only, so messages such as "Trust you are well" were written across the front.

PINEY WOODS ROAD, WINTER PARK, FLA.

C. KROPP. MILWAUKEE.

Since Winter Park had very little development to sell in its early years, its founders sold potential buyers on its atmosphere. They wrote in their prospectus, "The wonderful healthfulness of the climate of Winter Park is due to its high altitude, freedom from swamps, perfect drainage, ocean breezes which sweep away fogs and malarial germs, and lastly, the absolutely pure water found in its lakes, springs and wells. Hundreds of people can be found in Winter Park who will testify that they have been either cured or greatly relieved of asthma, bronchitis, catarrh, and even consumption, by living here. The effect of the climate upon lung and throat troubles is wonderful."[3] Winter Park's "high altitude" is all of 92 feet above sea level; but as you can see from the vintage card on this page, altitude was still a bigger selling point than the state of Winter Park's main thoroughfares. It wasn't until 1898, by the way, that it was established that malaria was caused by mosquitoes, not "malarial germs."

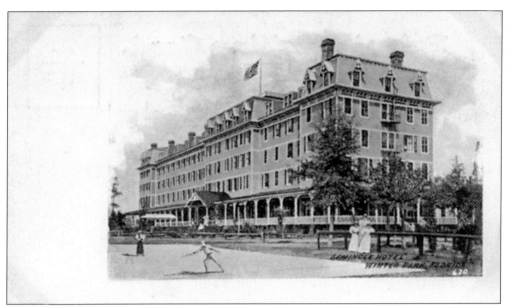

Just five years after the founding of Winter Park, a most astonishing building arose above the town. The Seminole Hotel opened for business on New Year's night, 1886. With five floors and an elevator, it was the largest hotel south of Jacksonville. In its first three months of operation, 2,300 visitors stayed at the hotel, and many others were turned away. This "postal card" is dated 1898. (Courtesy of Russell V. Hughes.)

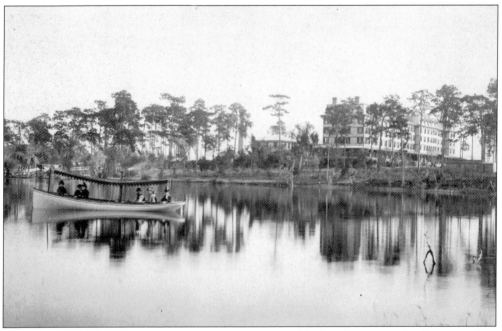

This postcard shows Seminole Hotel guests enjoying one of the hotel's steam yachts; however, they could also use the hotel's sailboats or rowboats. In addition, the 250-room resort had a bowling alley, tennis courts, a croquet lawn, a billiard hall, and a full orchestra. In 1894, the hotel added electric lighting, and that had to improve the billiard games. (Courtesy of Rollins College.)

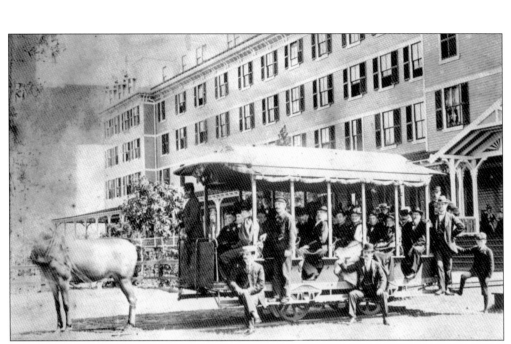

Guests of the Seminole didn't have to walk the sandy streets from the train station to the hotel. This horse-drawn trolley plied a regular half-mile route between the two, along what is now New England Avenue. Long distance rail service was excellent as well; by 1888, you could take a sleeper from New York to Winter Park without changing trains. (Courtesy of the Florida State Archives.)

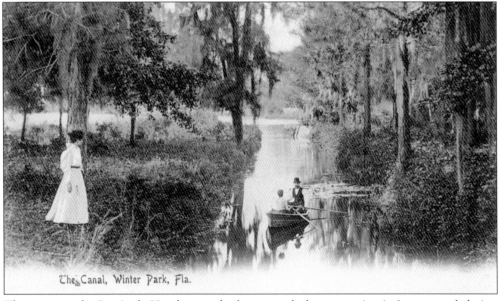

The Canal, Winter Park, Fla.

The season at the Seminole Hotel was only three months long, opening in January and closing at the end of March, and during a visit guests dressed up in their best finery. The canal shown on this card is one of several among the Winter Park lakes built by the timber companies. Here, it is being used just for fun by these beautifully dressed vacationers, including the dapper man in the rowboat wearing a bowler hat.

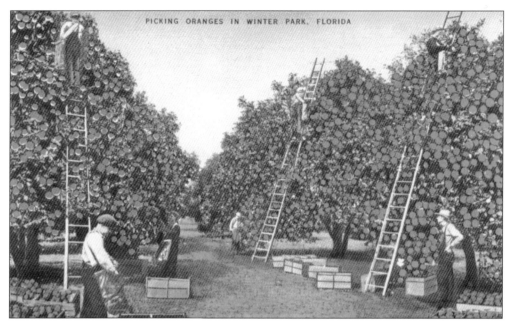

Surrounding the city were the citrus groves that served as Winter Park's second economic engine. By 1888, there were 40,000 orange trees within one-and-a-half miles of the Winter Park train depot. The writer Harriet Beecher Stowe, who had a home in Florida, claimed a single tree could yield 10,000 oranges in one year.[4] It should be remembered that she was a fiction writer.

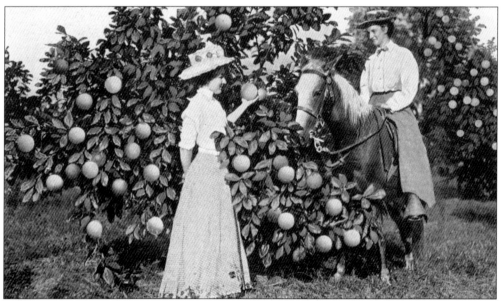

In the 19th century, the grapefruit was almost unheard of in the North. In 1887, Winter Park's Capen & Co. changed all that when its owner bought up all the grapefruit he could find and sold 190,000 to northern shippers at 1¢ each. He turned a tidy profit, but you could get 2¢ apiece for oranges. Notice the spelling of the fruit on this vintage card. (Courtesy of the Florida State Archives.)

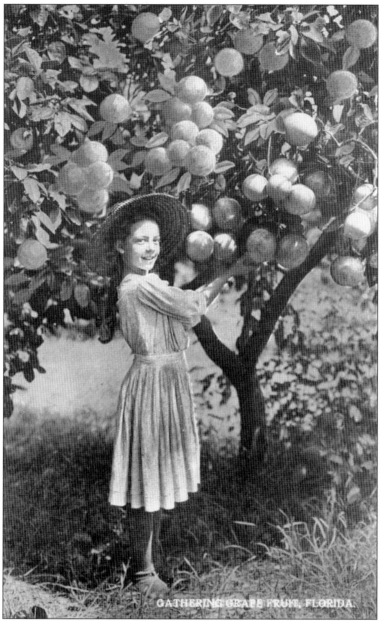

GATHERING GRAPE FRUIT, FLORIDA.

Citrus continued to be a delicacy in the 1880s and 1890s because people across the United States didn't get fresh fruit and vegetables all year, as people do today. In 1884, even with the proliferation of the railroads, it still took 34 days to get a load of oranges from Florida to Chicago, and by then a percentage of the fruit was ruined.[5] Consequently, citrus, with its brightly colored fruit and soft-scented blooms, continued to be an attraction for Florida visitors, as vintage postcards of the day show. On many postcards of the era, visitors marveled at the groves. One Winter Park visitor wrote home, "I love the smell of orange blossoms, which is in the air everywhere." The Winter Park Company advertised the city as "a collection of beautiful villas in the midst of the orange groves." The young lady in the large straw hat posing here "Gathering Grape Fruit In Florida" looks as sunny as the scene. (Courtesy of the Florida State Archives.)

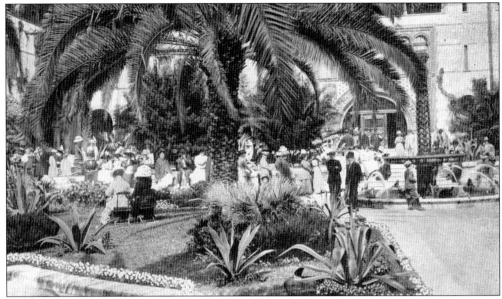

In 1889, millionaire Henry Flagler came to visit Winter Park. His Ponce de Leon Hotel in St. Augustine had opened a year behind Winter Park's Seminole, and it is possible he came to look over the competition. He arrived that winter in his private railroad car, bringing with him William Rockefeller, among other financial luminaries. Flagler's investments in Florida caused the state's first land boom. (Courtesy of the Florida State Archives.)

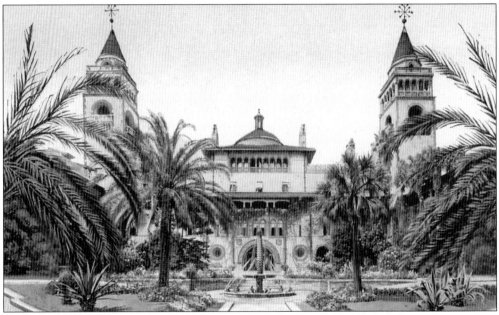

Flagler was in his 50s when he started his developments in Florida. He told reporters, "There was once a good old church member who had always lived a correct life, until well advanced in years he got on a spree. While in this state he met his good pastor. After being roundly upbraided for his condition he replied, 'I have been giving all my days to the Lord hitherto, and now I'm taking one for myself.' "[6] (Courtesy of the Florida State Archives.)

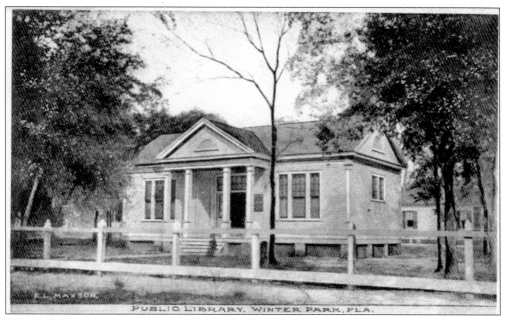

Winter Park residents were quick to establish a lending library, and just seven years after the city was founded, it could boast a library of more than 1,000 volumes. In 1901, construction began on the city's first library building, which opened in April 1902 at the corner of Interlachen and Fairbanks. The fence around the library must have been very helpful in keeping out those wandering hogs.

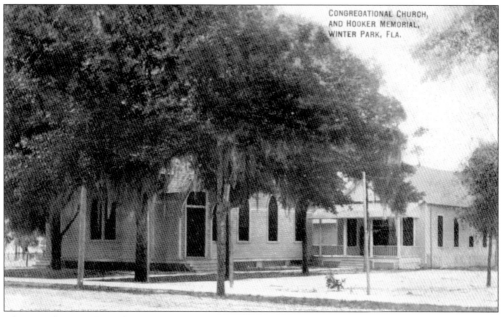

The city had its first church building in 1884 when services were held at the Congregational church. Things weren't quite ready—there was cloth on the windows in place of glass, and planks in place of pews. The Rev. Dr. Edward Hooker—later the first president of Rollins College—served as the church's pastor. His wife was president of the library.

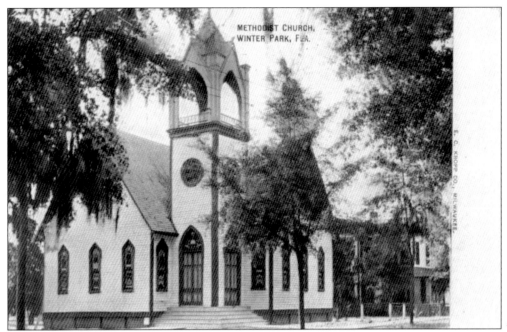

The Methodists met at the Congregational church until they dedicated their own sanctuary on Easter Sunday, April 5, 1896. After attending one Easter service, diarist Mary Brown—who was an Episcopalian but worshipped at several of the local churches, and who was always known for her frankness—wrote the following in her diary: "14 present. Nearly all late."

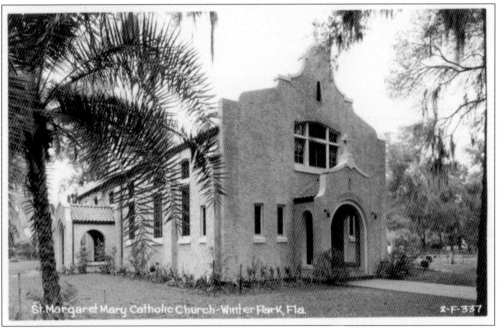

The Roman Catholic community held its first mass in a local home, and it was not until the 1920s that the Catholics had their own mission church in Winter Park. It was a lovely little building, just around the corner from the present sanctuary, facing onto Canton.

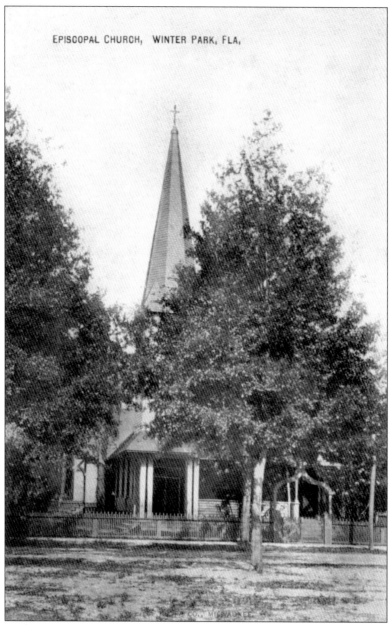

EPISCOPAL CHURCH, WINTER PARK, FLA.

In 1885, the Winter Park Company donated the land for the Episcopal church at Interlachen Avenue and Lyman. The church was organized as All Saints Episcopal Church and held its first service on Christmas Day 1886, with the Rev. Canon George C. Street presiding. The Winter Park Company felt the community needed to have churches for its winter visitors and promoted the fact in its 19th-century guidebook: "There are three church organizations in Winter Park, and ample facilities are provided for the accommodation of church-goers within 3 minutes' walk of the Seminole."[7] Bishop Henry Whipple of Minnesota had a winter home in Winter Park, and he helped out with pastoral duties at All Saints. Winter Park pioneer Mary Brown (the keen observer of latecomers to Easter service) was the daughter of an Episcopal missionary and a founding member of All Saints.

21

At the center of the city, Winter Park's designers created Central Park to add charm to their resort. One early visitor wasn't impressed and wrote, "I remember landing in Winter Park on a dingy little wooden structure which was the depot and facing a park that was unkempt."[8] He must have caught Central Park on a bad day.

The original plan was to plant the park with tropical fruits and flowers to look as it appears on the previous card. But shade trees were also planted, and as they grew, the look changed. This card's sender noted with glee in January 1924, "Today seems like a beautiful day in June, warm but not hot and everything beautiful under the glorious sunlight."

At one time, there was even a tennis court in Central Park. Generally, the status of the park depended a great deal on the economy. In 1936, when the Great Depression caused cutbacks, resident R. B. Barbour stepped in with a beautification plan. The Winter Park Garden Club helped out too, adding a rose garden, a stone seat, a sundial, and a birdbath.

WP-28 PETUNIAS IN MUNICIPAL PARK, WINTER PARK, FLA.

There were alligators and turtles in a pen in the park for a while, probably placed there because these exotic creatures were always interesting to visitors. They were removed in 1918. The person who sent this card sounded a forlorn note in January of that year when he wrote, "This is what we might have seen if there hadn't been a Florida freeze!"

INTERLACHEN AVENUE, WINTER PARK, FLA.

"Winter Park did not 'just grow,' " wrote Orange County historian William F. Blackman in 1927. "It was predetermined and guided."[9] The city's founders laid out wide avenues and set aside land for hotels and schools, as well as for Central Park. In this vintage card, Interlachen Avenue doesn't look like much, but you can see the founders' foresight in the pretty line of trees they planted along the roadside.

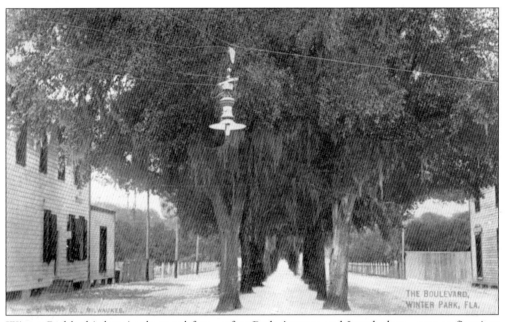

THE BOULEVARD, WINTER PARK, FLA.

Winter Park's third main thoroughfare—after Park Avenue and Interlachen—was at first just called the Boulevard. Now called Morse Boulevard, it was planted with a double row of trees down the center, designed to shade the sidewalk. Electric street lighting was installed in 1904, and the light shown on this vintage card is one of the early ones. The lights were designed to be taken down and stored during the summer.

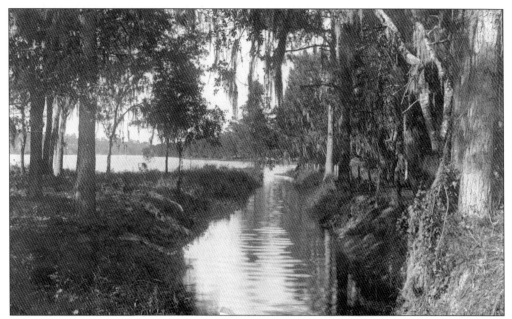

As is usual in the Florida climate, residents had to work hard to keep the lakesides from being taken over by the subtropical jungle. This card, which carries a 1910 Winter Park postmark, reads as follows: "I am sending you a picture of our canal after the brush has been cleared out. I think the lake (Osceola) looks pretty now. What do you think of our oaks, moss and orange groves in the distance?"

This visitor wrote, "This card shows you where I am but does not tell you how warm it is. 70° here this morning. All in summer dress, windows and doors all open, petunias and geraniums in bloom." It was February, and the sender couldn't resist adding, "I hope the weather has improved in Glens Falls."

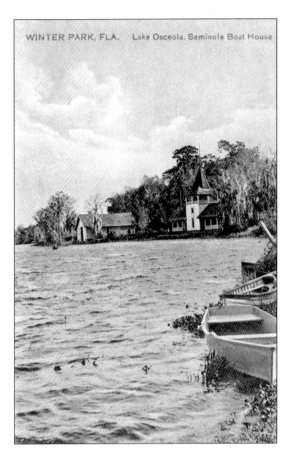

WINTER PARK, FLA. Lake Osceola, Seminole Boat House

As Winter Park chugged along into the 20th century, it carried with it some important advantages that would one day secure it a place as a first-rate city. Its economy was fragile, and that would be exposed in the coming years as economic difficulties threatened the tiny resort. First, Winter Park got some unexpected good news—news that would forever mark it as an important city on the Florida map.

Two

THE RESORT GOES TO COLLEGE

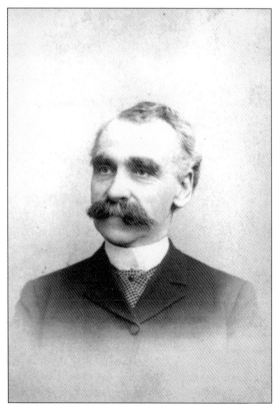

Alonzo Rollins was the next mustachioed magnate to make an impact on Winter Park. In 1885, the Congregational Association decided to build a college in Florida, and when Mr. Rollins pledged $50,000, Winter Park was chosen as the location and the school named after him. The city donated a lakeside parcel of land, originally set aside for a hotel, and the spot was stunning. Mr. Rollins had perhaps foreseen his need for a memorial; he died just two years later at the age of 55. (Courtesy of the Winter Park Public Library.)

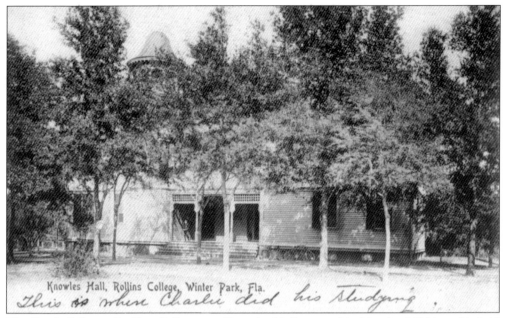

Knowles Hall, Rollins College, Winter Park, Fla.
This is where Charlie did his studying

The first building at Rollins College was Knowles Hall, opened in March of 1886, and it held both classrooms and offices. In attendance that year were 2 college freshmen, 8 college prep students, 3 students in the normal school, and 30 in the training school. The sender of this 19th century card notes, "This is where Charles did his studying." We have to hope so, since Knowles was the only building on campus.

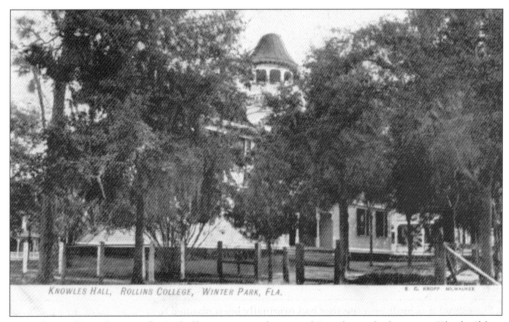

KNOWLES HALL, ROLLINS COLLEGE, WINTER PARK, FLA.

Knowles Hall was known for its bell tower, seen here peeking through the trees. The builders donated the bell for it in 1887, and it tolled for classes and meals and became a familiar sound throughout Winter Park.[1] Inside Knowles, a student could find all of the school's research equipment: a Bible, a dictionary, a ruler, and a thermometer.[2]

28

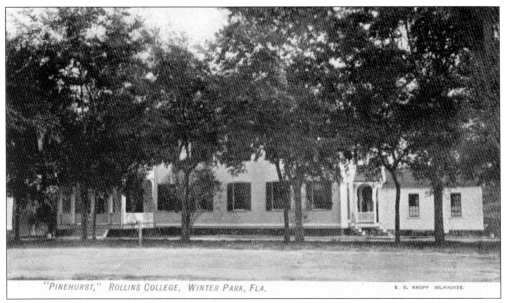

The first girls' dormitory was Pinehurst Cottage, built in 1886. Tuition that first year was $16 per term, with $56 for board and an additional $10 for a furnished room with a light. (Light was produced by gas in those days, and that cost money; so, presumably, a student on a tight budget could get an unlighted room and study by candlelight.) For a time, Pinehurst also housed the school's library in an unused kitchen.

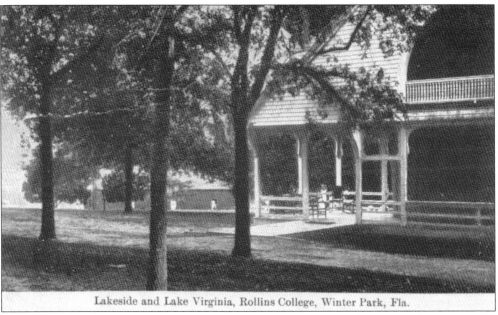

Lakeside and Lake Virginia, Rollins College, Winter Park, Fla.

The school was built on a site that had originally been planned for a hotel, so its location on the shore of Lake Virginia was spectacular. Boys stayed at Lakeside Cottage, which also opened in 1886. Nearby, on the water's edge, there was an abandoned sawmill full of sawdust and debris that spoiled their view. One night, with the help of science professor Dr. Thomas R. Baker and some gunpowder, students blew it up.[3]

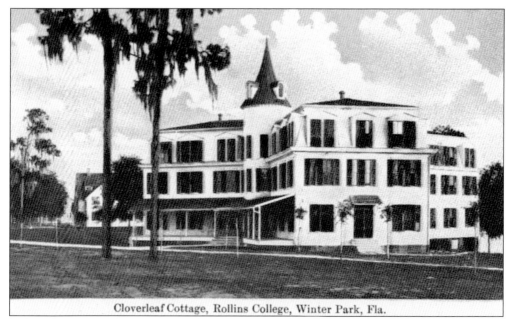

Cloverleaf Cottage, Rollins College, Winter Park, Fla.

The second girls' dorm was Cloverleaf Cottage, built in 1890 and shaped as its name suggests. There were 70 students at Rollins that year, the majority of them taking preparatory and sub-preparatory courses. That was because there weren't many other schools in Florida at the time, for students of any age, so Rollins provided instruction for many levels of students.

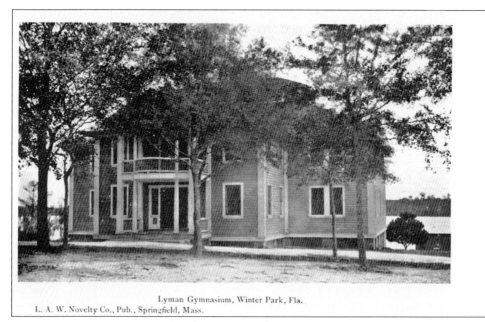

Lyman Gymnasium, Winter Park, Fla.
L. A. W. Novelty Co., Pub., Springfield, Mass.

Lyman Gymnasium was completed in August of 1890 but wasn't dedicated until February of the following year. It was named after F. W. Lyman, president of the Winter Park Company and first chairman of the board of trustees for Rollins. After great discussion, Rollins began permitting some coeducational physical education classes. It was still considered improper for women to go swimming.

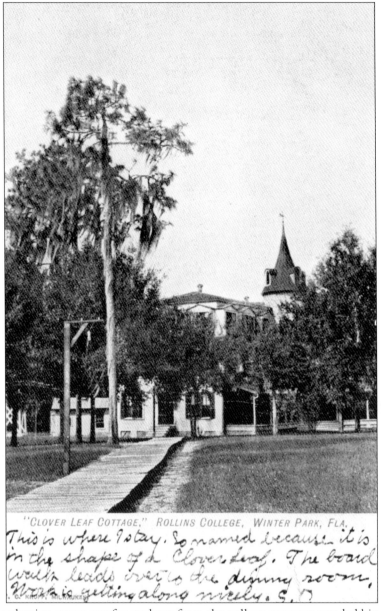

"CLOVER LEAF COTTAGE," ROLLINS COLLEGE, WINTER PARK, FLA.

This is where I stay. So named because it is in the shape of a Cloverleaf. The board walk leads over to the dining room. Work is getting along nicely. S. D.

The first graduation ceremony for students from the college program was held in 1890. Two students received their diplomas: Clara L. Guild and Ida May Missildine. The Rev. Dr. Edward Hooker, pastor of the First Congregational Church, had been appointed president of the college, and presided over the graduation. According to historian Claire Leavitt MacDowell, "No caps and gowns were worn. Pres. Hooker sat at a table on the platform, his snowy beard down to his chest, dressed in a Prince Albert coat buttoned closely about him; on the table beside him were his white kid gloves and tall silk hat."[4] In this postcard, mailed in 1900, you can see the boardwalk between Cloverleaf and the dining room, designed to keep students out of the Florida mud. The coed who sent this card to her family in Boston wrote, "Had a Masquerade Hallow'ene [sic]. Great fun. A Mr. S. and I were second in the grand march." The full name of the mysterious Mr. S. is lost to history.

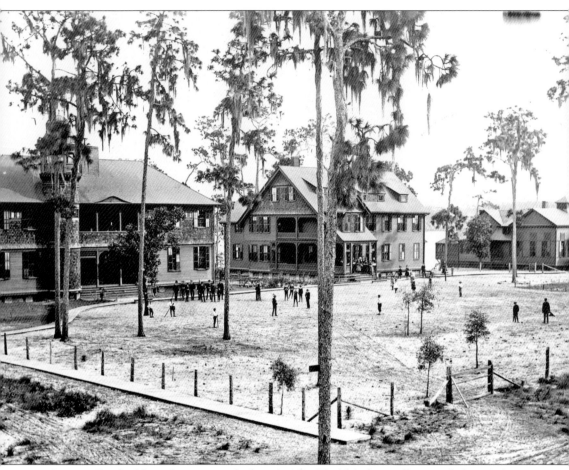

Orange City had hoped to secure the location for Florida's first college, and that city's paper wasn't kind when the choice was Winter Park. The editors of Orange City's *South Florida Times* wrote, "Winter Park is a place surrounded by swamps and about nine months of the year the hooting owls hoot to the few families that will forever be the only inhabitants of Winter Park."[5] This 1888 photo is the earliest known photo of Rollins College, and in Orange City's defense, the campus does look as though it might contain a hooting owl or two. Surrounding the commons is a fence, which might have been put there to keep footballs and baseballs from rolling out into the road. Rollins legend, however, says it was put there to keep out wandering cows. (Courtesy of Rollins College.)

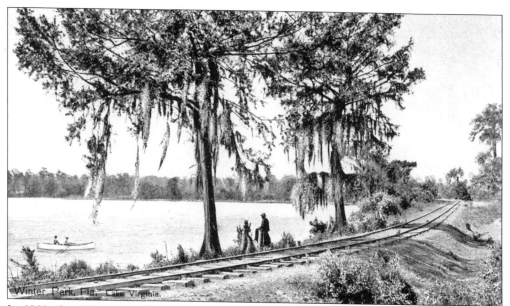

In 1889, the Orlando & Winter Park Railway began running on the five-mile route from a station on Lakemont Avenue, through Rollins, to downtown Orlando. Rollins donated right-of-way to the line in exchange for getting its own stop. It was a narrow-gauge line, and Rollins students nicknamed it the "Dinky Line." This postcard of Lake Virginia shows the Dinky tracks as they ran along the lake where Lakeview Avenue is today.

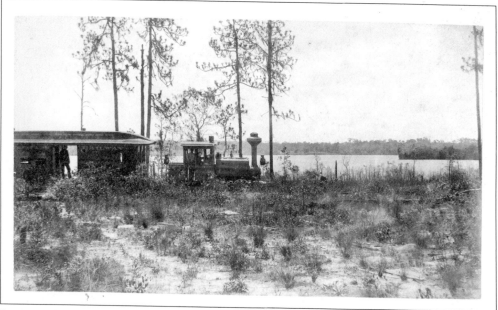

By 1901, the Dinky Line was one of 25 railroads in Florida. On most runs of the Dinky, there was just one passenger car, and though there are no color photos of it, longtime residents recalled that it was painted a bright yellow-orange. Notoriously slow, the Dinky managed to derail twice on its inaugural run, but the riders hopped down and helped lift the car back onto the tracks. (Courtesy of Rollins College.)

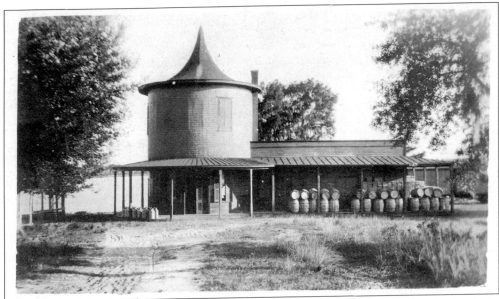

Donald A. Cheney (Rollins, 1907) wrote long after he had left Rollins, "Usually the single coach was filled with every seat taken and many standing in the aisle . . . and as the old wood-burner pulled out, the car was full of chatter and the sounds of revelry."[6] This is an old postcard of Winter Park's Dinky station. Dinky Dock Park marks its location today. Do you suppose those are barrels of beer? (Courtesy of Rollins College.)

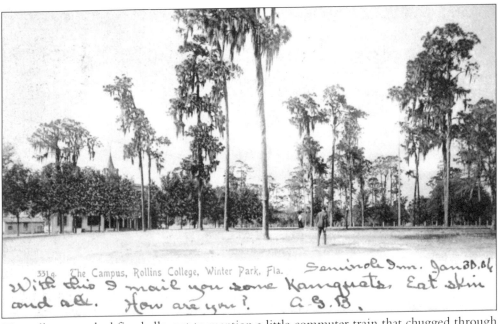

The college now had five halls, not to mention a little commuter train that chugged through campus. It does not yet look like a beehive of activity in this 1906 card. The sender writes, "With this I mail you some kamquats. Eat skin and all. How are you?" "Kamquat" is an early alternate spelling of kumquat—a Florida-grown citrus fruit exotic enough at the time to require eating directions. (Author's collection.)

The Boulevard, Rollins College, Winter Park, Fla.

In 1902, Dr. William F. Blackman became president of Rollins. He later wrote, "There were no lights on any of the streets. . . . There were no sidewalks. There was no garage in town and no automobiles. There were more pigs and cattle on the streets of Winter Park than there were people."[7] Still, things were looking up; Rollins had recently added the study of electricity to its requirements, replacing the history of France.

Conditions at the school continued to have that interesting Florida edge. Alligators lurked under the swimming dock in Lake Virginia, and poisonous snakes were not uncommon. In 1905, a group of Rollins boys held a snake hunting party. "They saw 40 snakes and killed 25, one a cotton-mouth moccasin which measured four feet, nine and one-half inches long and eight inches in diameter."[8]

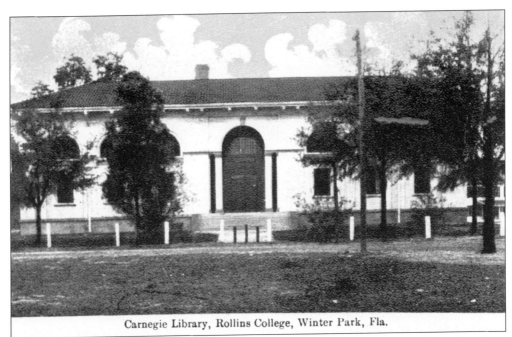

Carnegie Library, Rollins College, Winter Park, Fla.

In 1904, all of the Rollins buildings were wired for electricity. Just a few years later, the school got its first library, funded by a $20,000 grant from Andrew Carnegie. The college moved Cloverleaf about 80 yards to the southwest to make room for the new building.

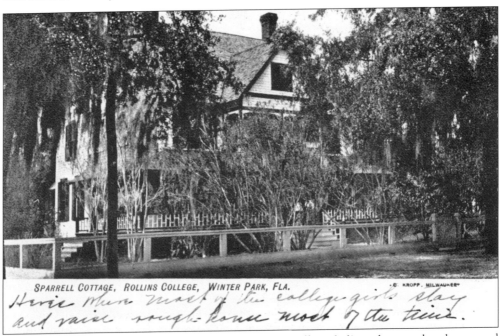

SPARRELL COTTAGE, ROLLINS COLLEGE, WINTER PARK, FLA.

After installing electricity and adding a new library, Rollins dedicated a new boathouse and opened Sparrell Cottage, given to the college by Miss E. G. Sparrell for use as an overflow dorm. The sender of this card, which was mailed in 1907, writes, "Here is where most of the college girls stay and raise rough house most of the time."

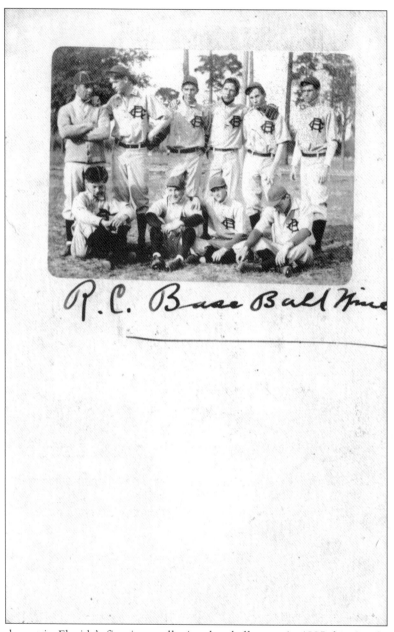

R.C. Base Ball Nine

Rollins took part in Florida's first intercollegiate baseball game in 1895, beating Stetson 11 to 10 on a field in Sanford. Rollins got its own baseball diamond and grandstand in 1897 and, beginning in 1908, won six straight Florida Intercollegiate Baseball Championships under the direction of coach Del Mason. Mason can been seen in the second row, far left of this vintage card that shows the 1906 Rollins team. The photo was probably produced by the photographer as a postcard so players could send it to friends and family. The large space at the bottom was designed so the sender could list the names of the nine team members. Our correspondent sent this card to Miss Esther Edmundson of Sutherland, Florida, without adding a message. He put only his initials on the address side of the card. Presumably, he knew Miss Edmundson would recognize him, and he didn't care if she knew any of the other guys.

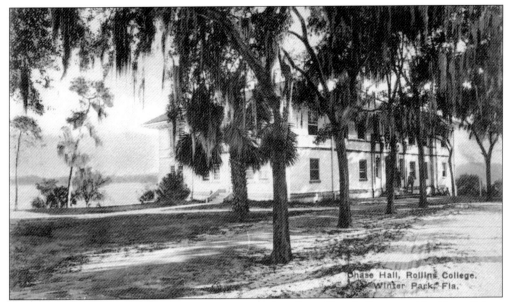

Winter Park founder Loring Chase died in 1906 and made Rollins College a residual beneficiary in his will, providing the school build a hall in his honor for "at least $10,000." The veterans of the 44th Massachusetts Regiment, who had served with Chase in the Civil War, contributed to the cost. To make room for this new hall, several more campus structures were moved by Arnout & Hopkins of Jacksonville at a cost of $1,650.

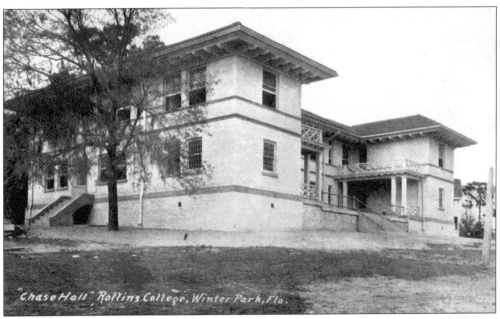

This postcard of Chase Hall shows it without a fence, and that may be because the City of Winter Park finally passed a "stock law" requiring residents to keep "horses, cattle, swine, sheep or goats" from running at large. During the day, cows were allowed to wander, but the city paid a young man $10 a month to keep them off the streets, and they had to be penned up at night.

Rollins College Campus.
Winter Park, Fla.

When teachers came to class on April 1, 1909, they found the classes empty of students. Signs reading "April Fool" had taken the place of the missing scholars. The young people did show up for dinner at the dining hall, as young people will, but that is when the teachers got their revenge. In place of the meal, there were signs reading "April Fool!"

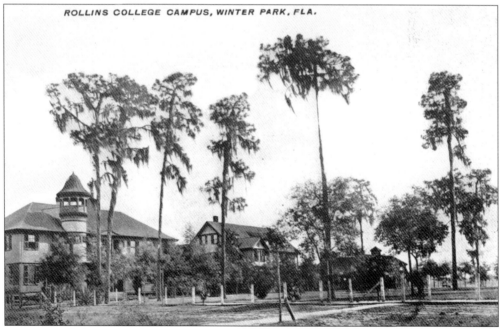

ROLLINS COLLEGE CAMPUS, WINTER PARK, FLA.

It was not all fun and frolic at Rollins that year. On December 2, 1909, a fire broke out in Knowles Hall, which contained all of the school's classrooms and offices. The all-pine structure went up like a torch in a blaze so hot it even melted the Knowles bell. The building was a total loss, and the school immediately began making plans to replace it.

39

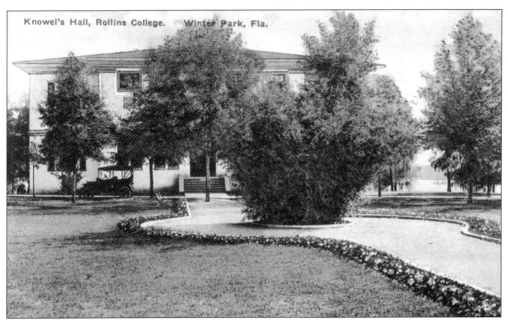

The new Knowles Hall—sometimes called Knowles II—was dedicated March 9, 1910. It contained a chapel for 350 people, a pipe organ, and two grand pianos. Science professor Dr. Thomas R. Baker had lost all of his scientific equipment in the fire. Hoping to mitigate the loss, local citrus grower L. F. Dommerich gave the science department a brand new telescope made in Germany. Note the misspelling of the hall's name on this vintage card.

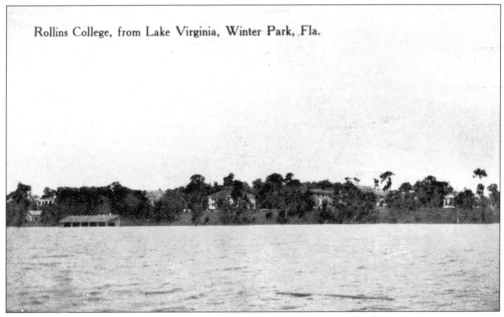

In its first two decades, Rollins College had established itself, and it had survived, but it had not truly begun to thrive. Its campus included just a cluster of buildings, and it had graduated just a handful of students. Rollins would see great times ahead. Before those times arrived, the school would have to endure some difficulties that would also test the strength of Winter Park.

Three

ICE AND FIRE

Florida Orange Blossom Time

PHOTO COURTESY FLORIDA CYPRESS GARDENS

On December 28, 1894, the mercury fell to 18 degrees Fahrenheit (-7.7 degrees Celsius) in Winter Park. The citrus crop was ruined, but the weather warmed and growers relaxed. Then, just six weeks later, on February 8, 1895, the temperature fell to 17 degrees Fahrenheit (-8.4 degrees Celsius), and this time, the cold was so severe, it killed the precious trees. Groves were abandoned and banks failed. The population of Winter Park, which peaked at 658 that winter, began to fall. In just one season, the business of citrus did not seem quite so sunny.

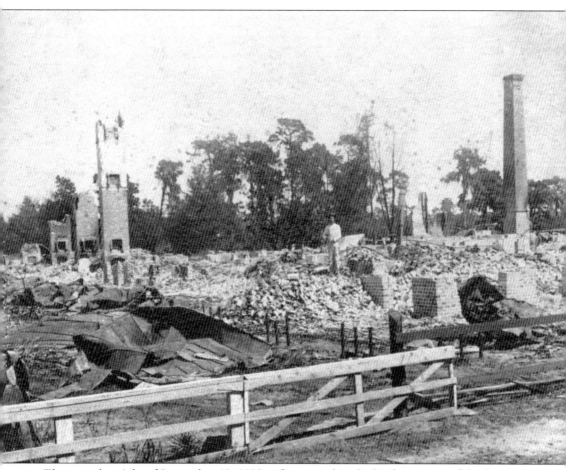

Then, on the night of September 18, 1902, a fire started in the kitchen annex of the Seminole Hotel. The building was made entirely of wood, and the fire spread so quickly that by the time someone reached the Orlando Fire Department, there was little the firemen could do. It was the off-season, so only a caretaker was on the property (it is believed he is the man posing in this picture), and he was able to get out safely; however, one local man died trying to retrieve furniture. The hotel was a total loss, and, worse yet, it had been insured for only a fraction of its value. First ice, then fire—Winter Park could not have faced two more serious blows in such a short time. During the 1894–1895 school year, enrollment at Rollins reached 195 students. By 1903, it dropped to just 175 students, with only one person graduating from the college program that year. Yet, Winter Park's hard times created an opportunity for the city, and for the man who would become the city's greatest benefactor. (Courtesy of Rollins College.)

Charles H. Morse had been coming to Winter Park since 1881 and had built a winter home on Lake Osceola. In 1904, he purchased a large part of the land owned by Winter Park's founders—property at a discount after the freeze and the fire. A 1914 visitor wrote the following on the card below, which depicts the grounds of Morse's estate: "Have just returned from a walk through this 'paradise.' Wish you could see it." Morse did not limit his kindness to letting visitors walk through his park. As the years went by, he would give much to Rollins College and to the city. By 1905, he was no longer just a winter visitor; he made Winter Park his full-time home. His house and his garden still stand at 231 Interlachen Avenue. (Photo at right courtesy of Rollins College.)

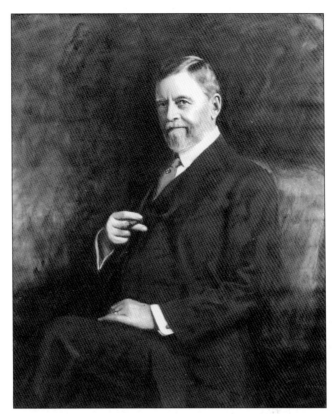

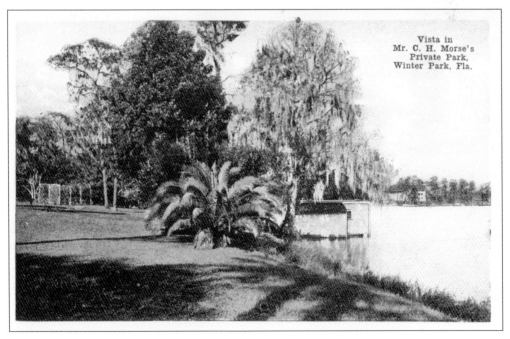

Vista in
Mr. C. H. Morse's
Private Park,
Winter Park, Fla.

43

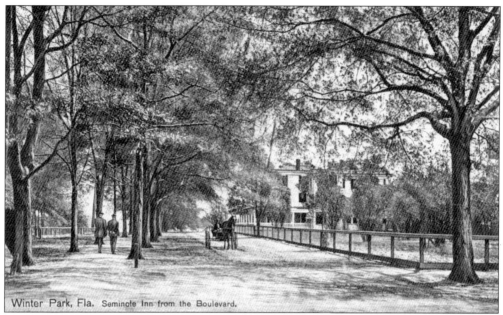

Winter Park, Fla. Seminole Inn from the Boulevard.

In 1904, the same year Morse invested heavily in Winter Park, he and several friends bought Rogers House, the small inn that had been Winter Park's first hostelry. The men renamed it the Seminole Inn—after all, the Seminole Hotel was gone and the name was up for grabs. Then, they gave the inn to Rollins College for its endowment.

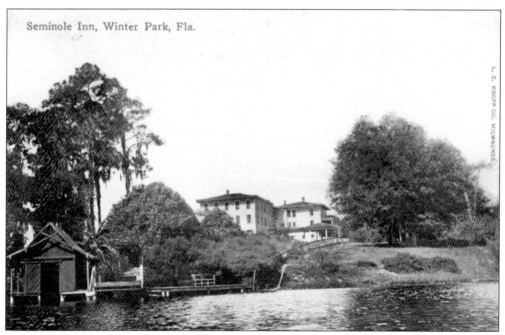

Seminole Inn, Winter Park, Fla.

The men also gave Rollins $9,050 for improvements to the inn, including the addition of steam heat, electric lights, more guest rooms, and 10 private bathrooms. Rollins owned the inn until 1912, when the trustees sold it to a new group of investors. The inn was just a short walk from Morse's home and continued to be his favorite place to dine for many years.

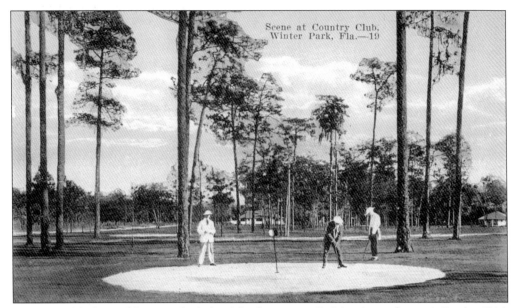

Scene at Country Club,
Winter Park, Fla.—19

Winter Park's first golf courses had clay (also known as dirt) in place of greens. But by 1914, Morse had donated the property for a new course, and the clay was replaced by grass. The sender of this card notes, "The golf grounds here are considered by outsiders the best in Florida. There's always someone on the grounds, even at night as the moon is beautiful at this time. Much nearer than it is up north."

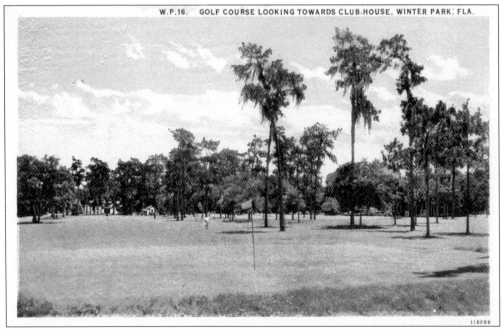

W.P.16. GOLF COURSE LOOKING TOWARDS CLUB-HOUSE, WINTER PARK, FLA.

The golf course was an additional asset that helped the business of tourism rebound in Winter Park during the years after the freeze and the fire. Still, it is impossible to please everyone. "Maybe this will put sweet memories in your mind," writes the sender of this card. "Although the greens don't look so hot." He should have seen the clay.

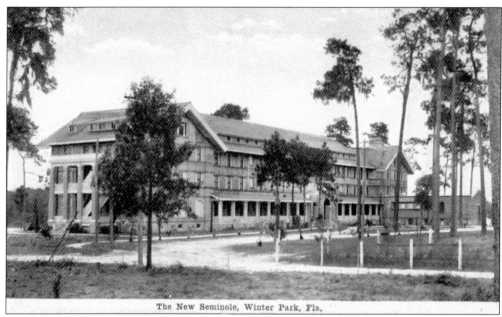

The New Seminole, Winter Park, Fla.

In 1913, there was more good news for Winter Park when investors opened a resort called the New Seminole Hotel. The property surrounding the old Seminole Hotel had been subdivided and sold for homes, so the new hotel was located across the lake on a site at the east end of Webster. "Winter Park is the next town to Orlando," writes a visitor on this card, "And a lovely place."

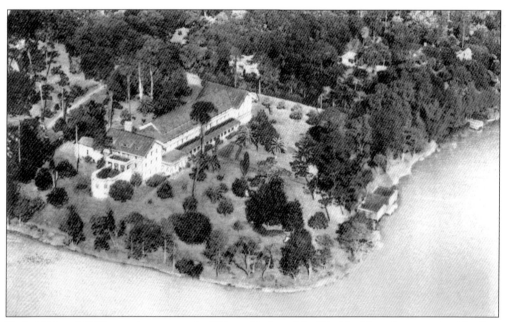

Both 1912 and 1913 were busy years for Winter Park and for Florida. The city organized its first volunteer fire department, and Flagler's East Coast Railway was completed through to Key West. These were also the last years of peace. In 1914, Germany declared war, and postcards, many of which had been hand-colored in Germany, would now come only from the United States. This aerial view of the New Seminole is an indication of the growing use of the airplane.

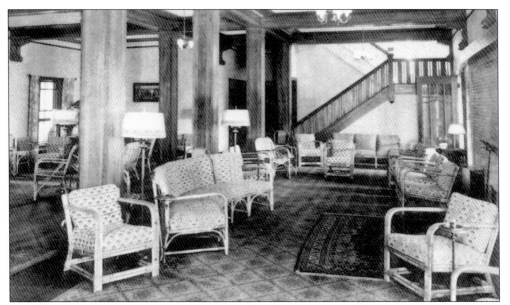

This vintage card shows the lounge at the New Seminole Hotel. The resort had 600 feet of frontage on Lake Osceola, its own private dock and boathouse, and the new innovation of telephones in the rooms. Two years after the opening of the new hotel, the population of Winter Park rebounded from a low of 450 to 757 full-time residents.

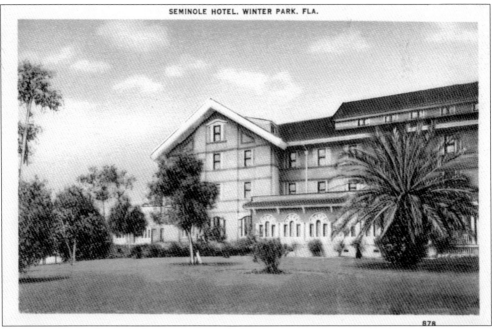

SEMINOLE HOTEL. WINTER PARK. FLA.

"I am spending a few months here in Florida, having a nice time eating oranges, grapefruit, and picking strawberries," wrote a visitor on this New Seminole card. "It is so nice to walk on the flats, and not on ice and snow," wrote another. In 1915, the name of the New Seminole Hotel was changed to the Seminole Hotel. The resort would continue to attract visitors for the next half-century.

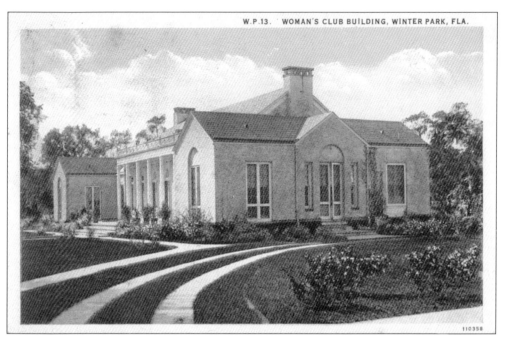

In 1915, a group of women formed the Woman's Club of Winter Park. The founding members included Mrs. Charles H. Morse and Mrs. William F. Blackman, the wife of the president of Rollins College. At first, until the clubhouse was built, the women met at the Winter Park Public Library and each other's homes. Very quickly the group began planning for its own clubhouse.

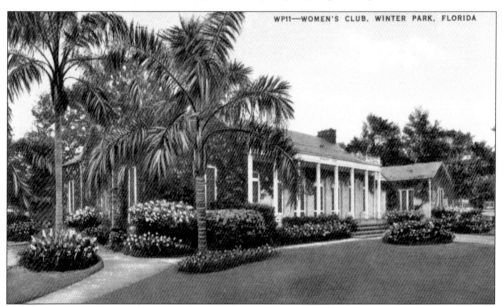

WP11—WOMEN'S CLUB, WINTER PARK, FLORIDA

With the help of Charles H. Morse, the Woman's Club of Winter Park was able to get its clubhouse built by 1921. It rose on a site that had been the first tee of one of Winter Park's earlier golf courses, and the pretty building remains there to this day. Note the misspelling of the club's name on this card. Because the club uses the singular "woman" in its name, this is a very common mistake.

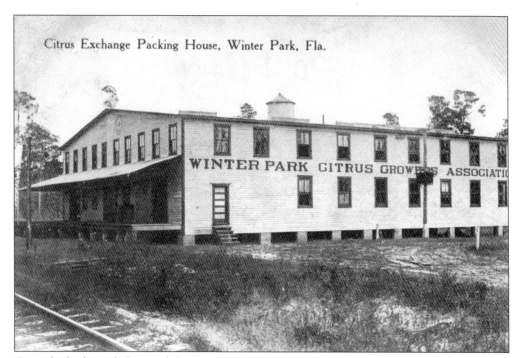

Citrus Exchange Packing House, Winter Park, Fla.

Citrus had rebounded enough by 1909 for Winter Park growers to build a new packinghouse along the railway. It had the capacity to load 6 railroad cars of oranges or 10 cars of grapefruit per day during the season. In 1914, a hybrid purchased after the freeze developed in the Winter Park groves of L. A. Hakes and was named after W. C. Temple. The Temple orange was unusual: "General shape and kid glove quality of the tangerine, color and odor of the pineapple orange . . . while the flavor is tender, juicy, sweet, and melting."[1] The sender of the 1907 card at right must have thought the citrus picture spoke for itself, since his comments refer to another Florida product: "The nuts are delicious, and so cheap!"

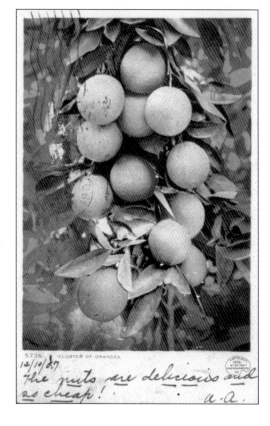

*Nothing small about Florida, no siree!
Not even the grape-fruit as you see.*

VERSE COPYRIGHTED BY ASHEVILLE POST CARD CO.

Citrus was big all right. During World War I, the women of the Winter Park Woman's Club got together—and got their fruit together—and made 700 pounds of marmalade to send to wounded soldiers in France. And though the grapefruit was now well known up North, there was still some disagreement about the spelling, as this card suggests. (Courtesy of the Florida State Archives.)

PICKING ORANGES IN FLORIDA

By 1920, the appropriately named Orange County—of which Winter Park was and is a part—was producing 800,000 boxes of oranges from 435,662 trees and 155,000 boxes of grapefruit from 62,000 trees.[2] The residue from the groves, unfortunately, attracted an awful lot of flies, and Winter Park held a contest to stamp them out. Corbet Dodd won first prize and a pair of new shoes for bringing in 2,200 dead flies, the city record. (Courtesy of Rollins College.)

50

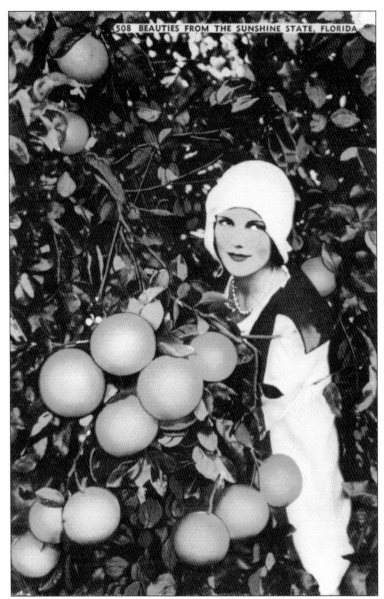

A new market for citrus was on the horizon, and one of the pioneers was Winter Park resident H. A. Ward, who, with a group of partners, founded the Florida Citrus Juice Company. The two big world wars in the 20th century spurred the industry; soldiers have to be fed, and citrus juice and juice concentrate turned out to be two of the most efficient ways of getting vitamin C to soldiers. By the 21st century, citrus juice would account for 94 percent of Florida's citrus business. There were other changes ahead too; beginning in the 1920s, Florida land became so popular for development that people began buying and selling orange groves to subdivide into building lots. One example of this in Winter Park was the purchase by Hal David Cady of the Kedney groves on Lake Maitland from H. A. Bourne. Cady made plans to develop the groves into homes almost immediately.[3] Still, it would always be hard to top the "beauties from the sunshine state." (Courtesy of the Orange County Regional History Center Research Center.)

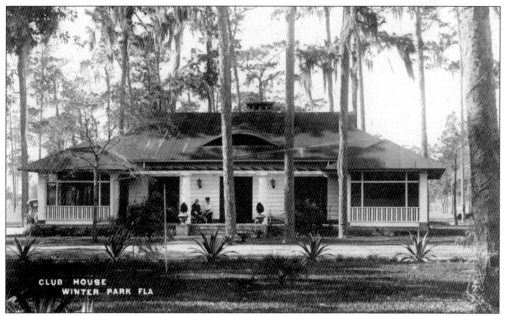

In 1900, a group including C. H. Morse, met for the first time to form the Winter Park Country Club. In 1905, members voted to build themselves a clubhouse, but it wasn't until 1914 that the city issued a building permit for its construction. Budgeted at $3,500, it was one of the first golf clubhouses in a state that would one day abound with them.

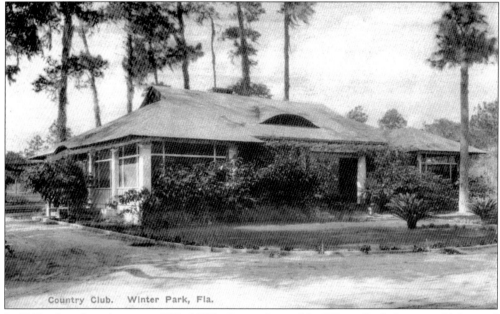

In 1917, when America entered World War I, members of the Winter Park Country Club voted to do their bit, placing 250 sheep and 150 goats to graze on the golf course in order to ease the shortage of meat. The Winter Park Country Club is now owned by the City of Winter Park, and the clubhouse is on the National Register of Historic Places. The sheep and goats gave their all for the war effort long ago.

In 1913, Winter Park began to pave its roads to accommodate the automobile. Webster, ending at the Seminole Hotel, was one of the first to be paved. Initially the paving was done with clay, but in 1915, Winter Park paved its first street with bricks. Today, the six miles of brick streets in the city are beloved by many and disliked by others for their bumpy ride.

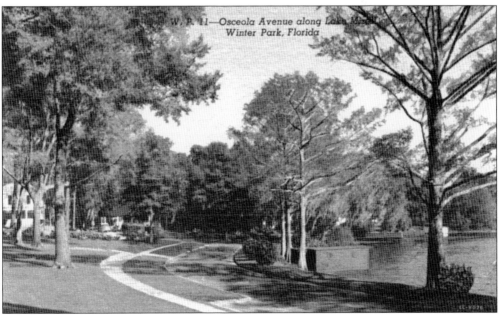

Winter Park passed an ordinance in 1903 that set a speed limit of eight miles per hour for "any motorcycle, automobile, or bicycle run by steam, gasoline, naptha or any motor power."[4] In 1913, the city raised the speed limit to 15 miles per hour on busy streets and 20 miles per hour on open roads—pretty close to the limits Winter Park drivers ignore today. The bumpy brick does slow down the occasional car to the actual speed limit.

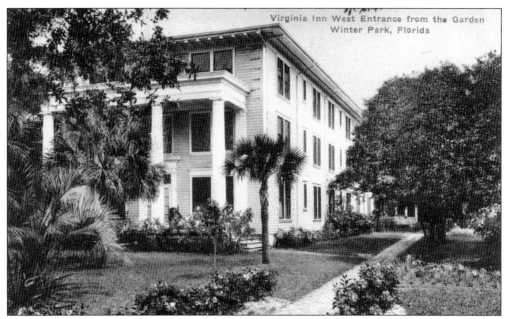

In 1914, after the construction of the New Seminole Hotel, the Seminole Inn (first called the Rogers House) changed its name to The Inn. In 1915, it changed its name again (and for the final time), becoming the Virginia Inn. Why it was called the Virginia Inn, though it faced Lake Osceola not Lake Virginia, is one of Winter Park's many curiosities.

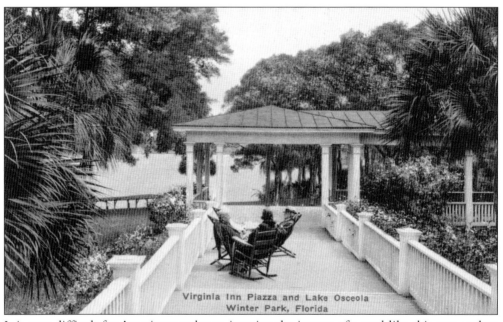

It is very difficult for Americans today to imagine the impact of a card like this one—when it arrived in the middle of winter—on friends and family in the North. Air travel had not yet made it possible for vacationers to zoom from one climate to another in a matter of hours. This visitor to Winter Park wrote to a friend in Wisconsin, "Like it here very much. I am afraid it will spoil me so I shall not want to live up north anymore!"

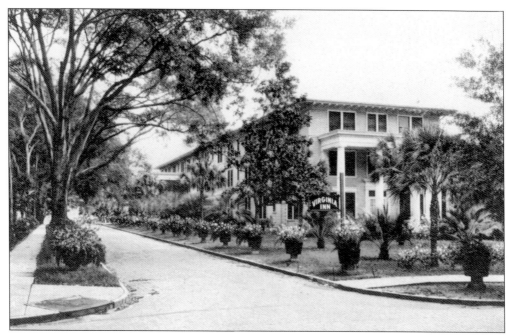

Just before World War I, hitching posts were removed from the downtown streets, and the city began requiring businesses and residents to put in sidewalks. Both decisions improved the look of the sleepy resort. Automobile travel brought more visitors. "Reached here today AM," wrote one guest of the Virginia Inn. "After driving 1140 miles, I was ready to sit on this porch."

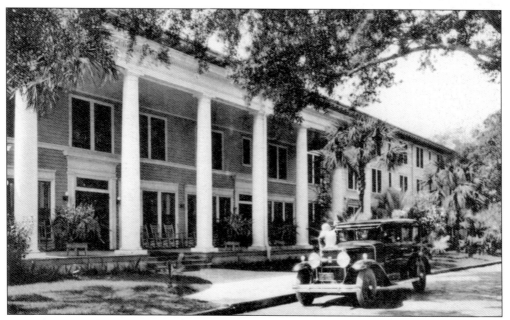

Over the years, the Virginia Inn continued to attract a loyal clientele. From Pres. Chester A. Arthur in 1883 (who probably only came to dine, during his stopover in Winter Park by train) to Liberace in 1962, the inn was a longtime popular vacation spot. Liberace didn't arrive in that Packard, but it seems very likely he would have warmed up to it.

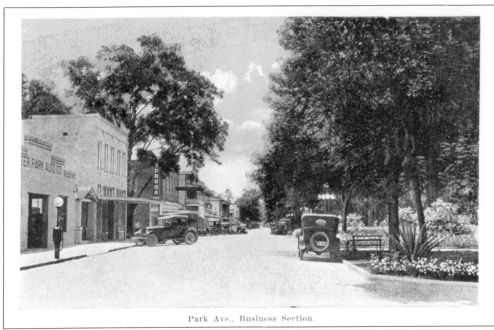

Park Ave., Business Section.

The end of World War I began a decade of growth and prosperity both for Winter Park and the nation. A new public school went up at Park and Lyman. On the back of this 1921 card, the sender added this original message: "Gee I wish you were here with me. I'm having a wonderful time."

The year 1921 brought with it the passing of Charles Hosmer Morse. He had nurtured Winter Park through both good times and bad. Near the time of his death, a Winter Park visitor wrote a description of the city, which Morse might have endorsed: "The perfume of the orange blossoms, the singing of the mocking birds, the beauty of every scene, combine to make me wonder whether I am not in Paradise."[5] (Courtesy of the Winter Park Public Library.)

Four

HOME, COTTAGE, AND CASA

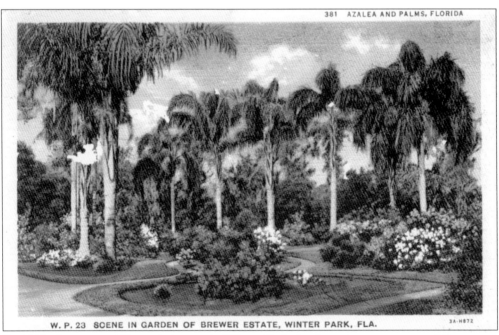

381 AZALEA AND PALMS, FLORIDA

W. P. 23 SCENE IN GARDEN OF BREWER ESTATE, WINTER PARK, FLA.

3A-H872

By 1910, there were 132 stately homes in Winter Park. In the early years, many of them were winter cottages. None were what most people today would call cottages, but the word was popularized in the 19th century to describe the vacation homes of the well-to-do. Edward H. Brewer, of Cortland, New York, built one of these on Lake Osceola in 1898 and called it "the Palms." This card includes the rhyme, "The orange trees are fragrant/The pines stately and tall/But the palms that never change/I love them best of all."

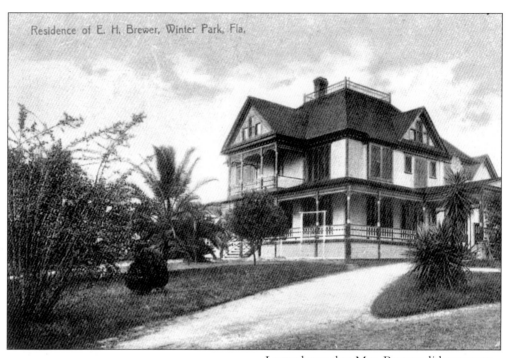

Residence of E. H. Brewer, Winter Park, Fla.

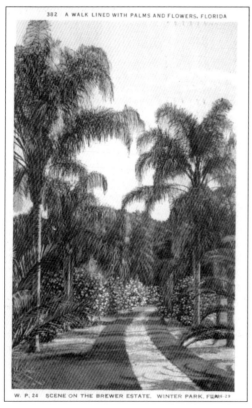

382 A WALK LINED WITH PALMS AND FLOWERS, FLORIDA

W. P. 24 SCENE ON THE BREWER ESTATE, WINTER PARK, FLA.

Legend says that Mrs. Brewer did not want to come to Winter Park, and in order to persuade her, Mr. Brewer made their Winter Park home an exact copy of their New York mansion. The 1909 card showing the home, (above) was addressed, "Mr. Ray Trovillion, Winter Park, Florida." Trovillion was the son of Winter Park's pharmacist. Even with this limited information, the postman must have known where to find him. Many of the postcards of Winter Park estates are of the grounds only. Not everyone wanted his house on a postcard, and not all of the homes could be seen and photographed from the road. The visitor who sent the card at left was able to tour the Brewer estate and wrote, "The gardens look just like this. Nice and warm here. You should live here where the sun shines all the time."

329. A NATURAL HEDGE OF FLOWERS, FLAME-VINE AND HIBISCUS, FLORIDA.

W.P. 11. SCENE ON THE BREWER ESTATE, WINTER PARK, FLA. 105486

According to Blackman's *History of Orange County, Florida*, Brewer originally paid $6,500 for 50 acres of his property, purchased from Alonzo Rollins. After the freeze, local resident Fred Ward was reportedly able to buy the house and its accompanying 50 acres for $500.[1] The Palms—very much remodeled—still stands on Winter Park's Trismen Terrace.

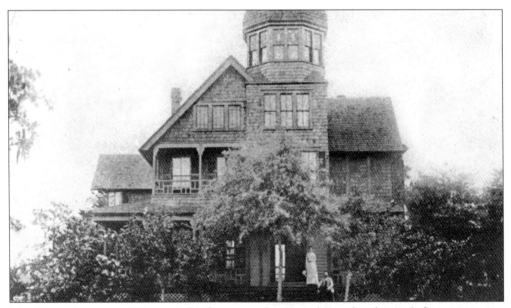

John Ergood operated Winter Park's first general store and was also the city's first postmaster. The home he built in 1887 was at 656 Interlachen, later to be the location of the famous Casa Feliz. Ergood himself can be seen in this postcard sitting on the steps of his home. Though he was a full-time resident, he nevertheless called his place Ergood Cottage, probably hoping to be just as posh as his winter customers.

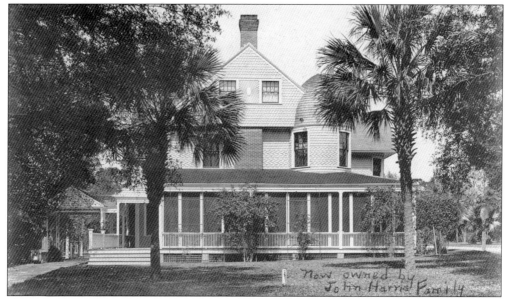

Eastbank was an estate on (as you might suspect) the east bank of Lake Osceola. It was owned by Chicago businessman William Charles Comstock, who came to the Winter Park area in 1876. In 1882, he purchased 60 acres of prime land on the lake and began building what would become one of the grandest of Winter Park's cottages. It can still be seen today at 724 Bonita Drive. (Courtesy of the Winter Park Public Library.)

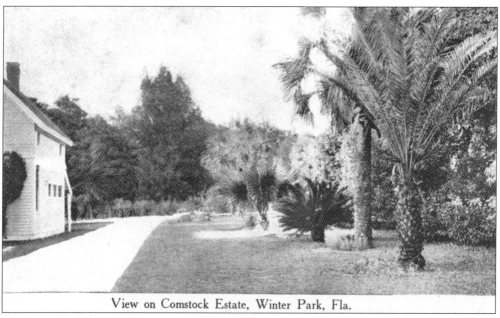

View on Comstock Estate, Winter Park, Fla.

This is another one of those postcards of a Winter Park estate that shows only the grounds. Eastbank had three floors, five bedrooms with private baths, and stained-glass windows in the stairway. The Comstocks continued to keep their primary residence in Chicago, where W. C. Comstock served as president of the Chicago Board of Trade from 1875 until his death in 1924.

60

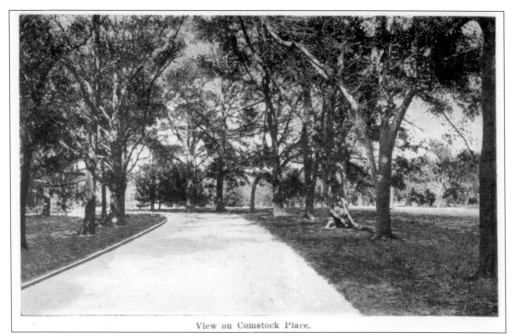

View on Comstock Place.

The private lane that was once Eastbank's entrance driveway has become Bonita Drive today. The house is one of just two private homes in Winter Park on the National Register of Historic Places. The other one is the Palms, built by E. H. Brewer. You can still see the line of camphor trees planted by the Comstocks, along Bonita.

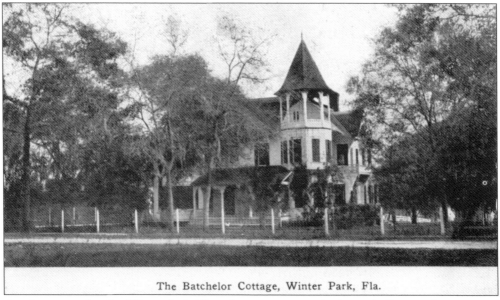

The Batchelor Cottage, Winter Park, Fla.

Another example of a Winter Park Victorian cottage was the home built near the corner of Osceola and Ollie by citrus grower Richard Neal Batchelor. The home cost $7,000 in 1883 and was sometimes called Seminole, as it could be seen easily from the old Seminole Hotel. In 1957, it became a Rollins dorm, and it was demolished in 1960 to make way for the Sutton Place South apartments.

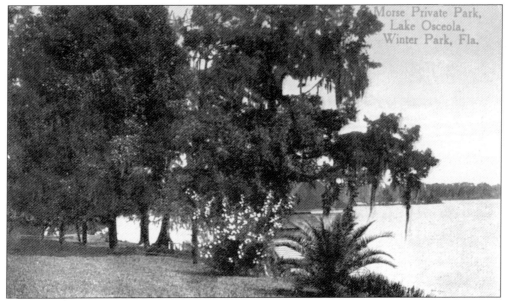

After the death of C. H. Morse in 1921, his daughter Elizabeth and her husband, Dr. Richard Genius, used Morse's Osceola Lodge, at 231 Interlachen, as their home for a time. The grounds continued to be known for many years as the "Morse Private Park," as it is identified in this postcard. Elizabeth's daughter, Jeannette Genius McKean, would one day continue the philanthropic work of her grandfather.

Elizabeth Morse Genius and her husband also inherited 150 acres of orange groves from C. H. Morse on the eastern shore of Lake Virginia. Morse had purchased the land in 1920, shortly before his death, and had carved a road through it that was later known as Genius Drive. There had been a plan to subdivide the land and build homes there, but that plan would not be revived for another three-quarters of a century.

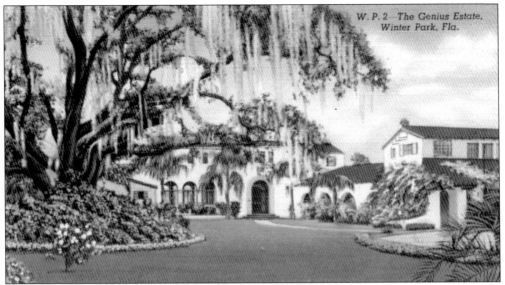

W. P. 2 The Genius Estate, Winter Park, Fla.

In 1938, Dr. Genius and his wife built a home at the end of Genius Drive on a piece of land across Lake Virginia from Rollins College. It was called, for a time, Villa Genius, and was later dubbed Windsong. The home remains, but a part of the surrounding property has been developed into the Windsong subdivision. Some of the acreage is undeveloped and has been set aside as a preserve.

View on Osborne Property.

This postcard—one of 18 in a 1924 folder—does not, unfortunately, show us the Osborne home. The only one on the Georgia Avenue property when these postcards were printed was built by Willis L. Osborne in 1905. After Willis died in 1937, Rockwell C. Osborne built a home on Georgia Avenue in 1939. When he died in 1946, the home was sold to Joseph Robinson. Both homes faced Lake Osceola. We'll just have to imagine how beautiful they were.

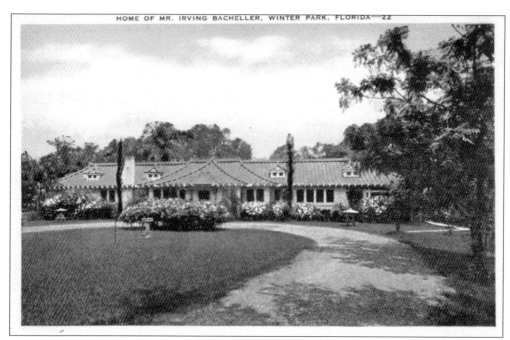

By the time writer Irving Bacheller, author of *Eben Holden*, came to Winter Park in 1917, home styles had changed considerably from those of the late 19th century. His Asian–influenced estate at 1200 North Park Avenue was called Gate o' the Isles.

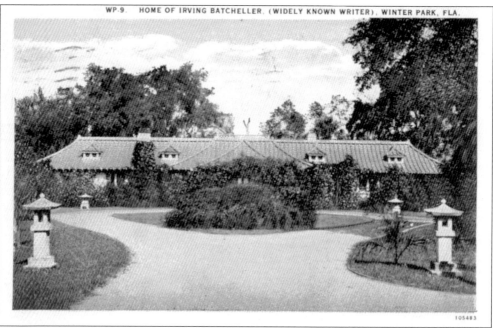

WP-9. HOME OF IRVING BATCHELLER, (WIDELY KNOWN WRITER), WINTER PARK, FLA.

Famous as Irving Bacheller was during his lifetime, his name was frequently misspelled on Winter Park postcards, as it is on this one. This was probably because the well-known family of citrus growers named Batchelor had lived in Winter Park a longer time. In this case, the card's producer joined the spelling of the two names, creating a third name that misspells both.

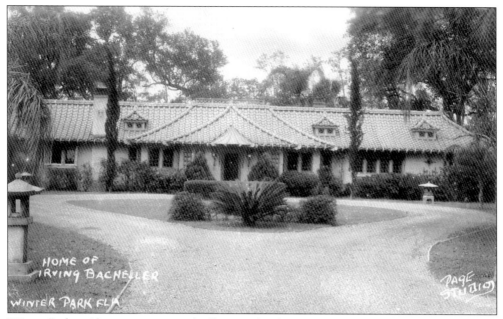

Winter Park residents were so proud of having this famous writer living in their midst that his home appeared on many souvenir postcards, as the four examples here show. Residents even named a street in Winter Park, Eben Holden Avenue, after his most famous book. Bacheller was also known for founding the first newspaper syndicate in America and for his work as editor of Joseph Pulitzer's *New York World*.

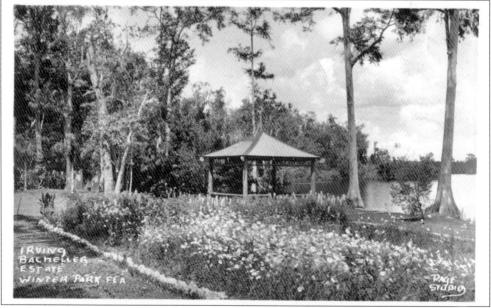

After Bacheller's death in 1950 at the age of 91, Gate o' the Isles was sold to millionaire A. G. Bush, who demolished it and built himself a new home on the property. Bacheller's books fell from fashion, and the name of Eben Holden Avenue was changed to just Holden. *Sic transit gloria mundi*—thus passes away the glory of the world.

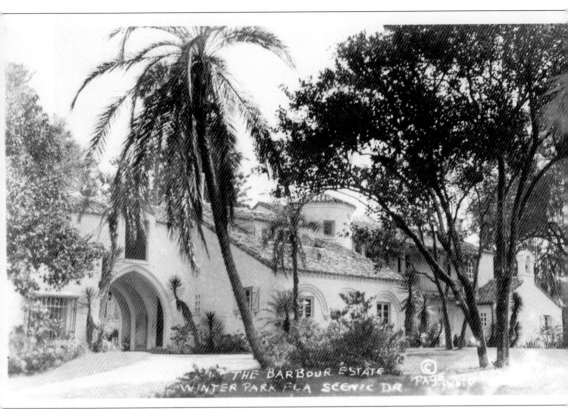

THE BARBOUR ESTATE
WINTER PARK FLA SCENIC DR

Winter Park's best-known home was built at 656 Interlachen on the property that had once been the location of Ergood Cottage. It was designed in 1932 by James Gamble Rogers II, a Winter Park architect of meticulous detail, for Mr. Robert Barbour. Barbour, who had made a fortune in liquid laundry bluing, was in Winter Park one day, saw a house he liked, and knocked on the door. The owner was Rogers, and he was just beginning his career. The two struck a deal. Barbour told the young architect how many rooms he wanted and left the details to Rogers, a commission Rogers called "an architect's dream." The architect chose to design an Andalusian cortijo, or Spanish farmhouse, on the beautiful lot that overlooked Lake Osceola. It was the nadir of the Great Depression, and the $25,000 project was a boon to Rogers, and in fact, to all of Winter Park. When the house was completed in 1933, Barbour was delighted, and photos of it appeared across the world in architectural magazines.

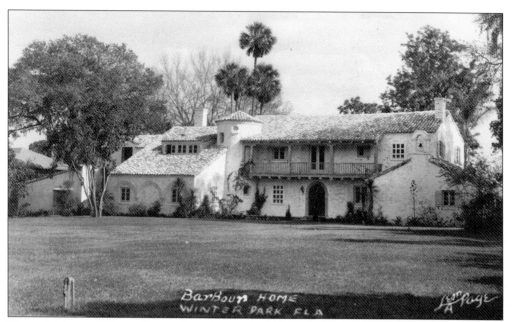

If you look carefully at the Barbour house, you'll notice the sag in the roofline. That was a device Rogers used to artificially age the house, creating a difference of about six inches between the center of the roof and each of the ends. The house became a great influence on the design quality of Winter Park homes—both because of its prime location and because the Barbours themselves were very well known.

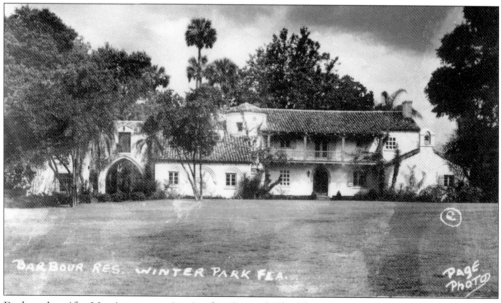

Barbour's wife, Nettie, was active in the Central Florida arts community and hosted many social events at the house, from symphony teas to poetry club readings. Once, the Barbours held a dinner honoring Pulitzer and Nobel Prize–winning writer Sinclair Lewis. The sender of this card in 1935 writes, "Went here to an afternoon tea the other day. Sloping down to a lake on the other side. Furniture like museum pieces. Hostess very charming."

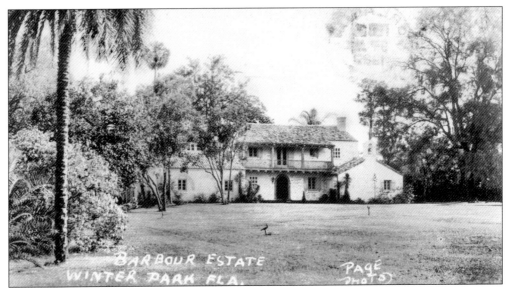

Later owners called the house Casa Feliz, or "house of happiness." In the year 2000, a new owner decided the house didn't make him happy and began to demolish it. Citizens rallied to save it, and the house was moved across Interlachen onto city land and lovingly restored by architect Jack Rogers, the son of James Gamble Rogers II. The fate that almost befell it led to the city's first-ever historic preservation ordinance.

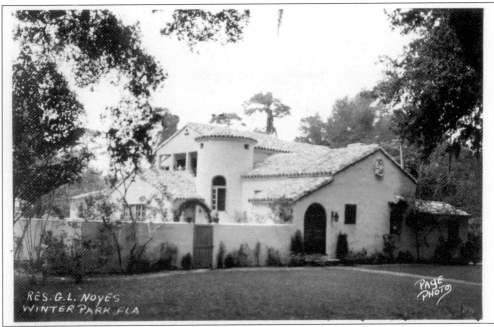

Nettie Barbour was interested in having the Barbour house furnished in an authentic style, so she sent local decorator Mabel Noyes to Spain to purchase antiques for the home. Noyes and her husband, the artist George Noyes, later commissioned their own house from James Gamble Rogers II at 617 Interlachen, and it was completed in 1934. Though originally only a one-bedroom house, it's a beauty.

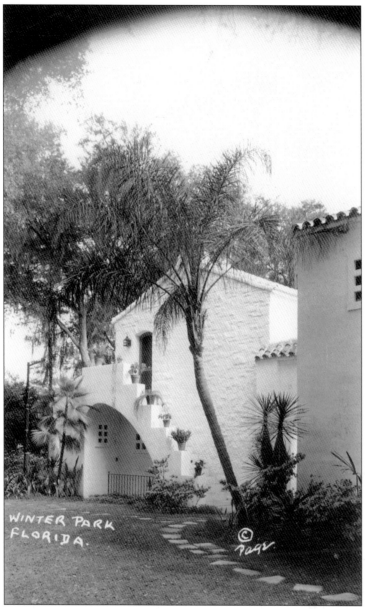

WINTER PARK
FLORIDA.

©
Page.

One more design came out of the Barbour house; Mr. Barbour asked Rogers to build some apartments that would look like "a street in Spain." The result was the Barbour Apartments at Knowles and Swoop. The small complex was a delight to the eye, and became immediately popular with winter visitors. The seven apartments were close to Park Avenue and the Winter Park Country Club and were less than a mile from Rollins College. They can still be seen today, and though they have been remodeled on the inside, on the outside they look very much as they did in 1938 when they were completed. Writers Patrick and Debra McClane, in their book about James Gamble Rogers II, comment especially on the beauty of the staircase, seen above: "The most distinctive feature of the building complex is the large gracefully arched stairway on the exterior of the west façade, facing Knowles Avenue. It is a beautiful expression of form, with its sinuously curved and stepped outer wall."[2]

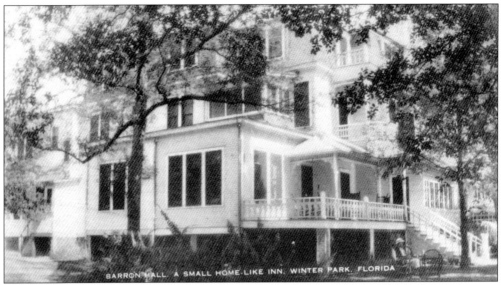

BARRON HALL. A SMALL HOME-LIKE INN. WINTER PARK, FLORIDA

Lifestyles changed in the first decades of the 20th century. Some of the huge vacation cottages were demolished, and others were adapted to fit the times. This single-family home was built in 1892 for Maj. W. G. Peck. After his death, Susan Peschmann ran it as a boardinghouse. In 1923, Maude Barron bought it and called it Barron Hall.[3] It may have been home-like (as the postcard suggests), but with 25 guest rooms, it wasn't exactly small.

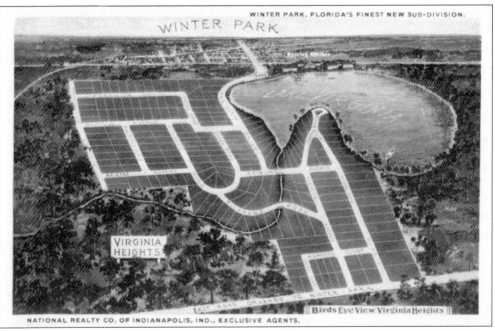

WINTER PARK, FLORIDA'S FINEST NEW SUB-DIVISION.

WINTER PARK

VIRGINIA HEIGHTS

Birds Eye View Virginia Heights

NATIONAL REALTY CO. OF INDIANAPOLIS, IND., EXCLUSIVE AGENTS.

The coming years would bring a wild land boom to Florida. Developments such as Virginia Heights ("Florida's Finest New Sub-Division") were cut from the groves and advertised on postcards like this one sent to the new market for Winter Park real estate—the American middle class. The boom brought with it changes to the city and to Winter Park's little college—seen here at the top of the postcard nestled against Lake Virginia.

Five

ROLLINS GROWS

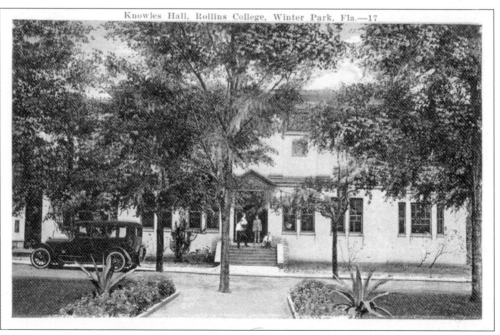
Knowles Hall, Rollins College, Winter Park, Fla.—17

Following World War I, Rollins headed into an exciting time. In 1919, the school became exclusively collegiate. In 1925, Rollins hired Hamilton Holt to serve as its president. The Yale graduate was internationally known, and he, in turn, knew America's elite. He made sure they all came to Rollins for his Animated Magazine, an event he conjured up that was full of lectures by the famous in just about every field. He gave Rollins a national reputation and made Winter Park home to the jewel in the crown of Florida's colleges.

Holt was from Connecticut, so he saw Florida with new eyes. He thought Spanish-Mediterranean buildings were what the school needed and said he would seek "the most beautiful buildings of the Mediterranean type in Florida, then find who designed them, then get that man to design every building on our campus. . . ."[1] In 1930, Holt was able to implement his idea when he received the approval to build Rollins Hall, seen on the vintage card below. He hired Miami architect Richard Kiehnel to design it, and the result was a building he felt was one with the "palms, bamboos, and brilliant sunshine"[2] he found in Winter Park.

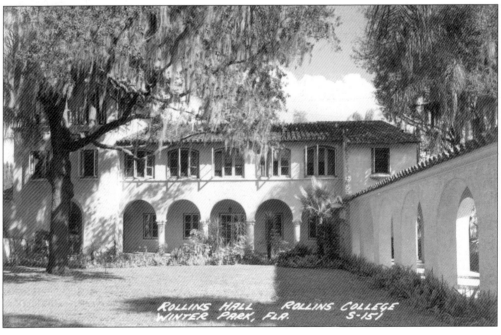

This is another postcard of Rollins Hall, dated 1937. The open walkway near the entrance is another example of Hamilton Holt's vision for Rollins; he thought its buildings should include open-air features to take advantage of Winter Park's beautiful weather.[3]

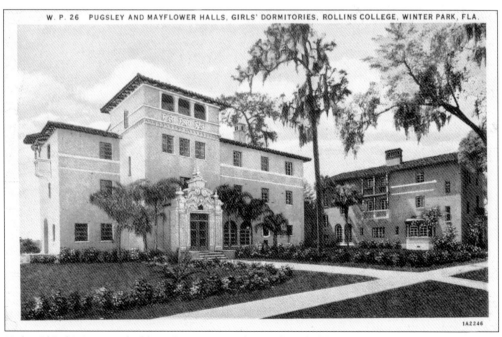

Holt said in his inaugural address, "We propose that Rollins shall become a shining exception to the rule that the greatness of a college is measured by the number of its students and the multitude of its buildings."[4] In spite of that statement, construction was almost constant during his tenure. After Rollins Hall, Mayflower and Pugsley were the next two new halls to be added to the school.

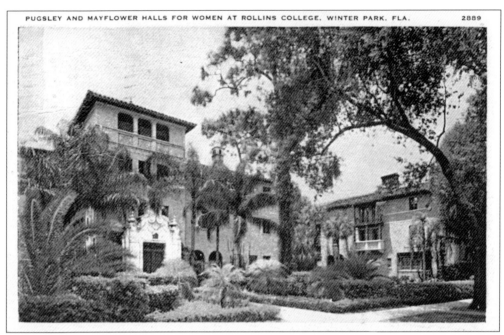

Hamilton Holt installed a piece of wood over the fireplace at Mayflower Hall that was believed to have been from the ship the *Mayflower*. In 2003, historian Judith Beale attempted to track down proof of its authenticity. She concluded that experts disagree.[5]

By 1931, there were 525 students at Rollins. They paid $400 in annual tuition and $415 for room and board. You could motor over to Winter Park's Abney's Coffee Shop and buy lunch for 30 cents. Future Rollins president Hugh McKean won a Rhodes Scholarship that same year.

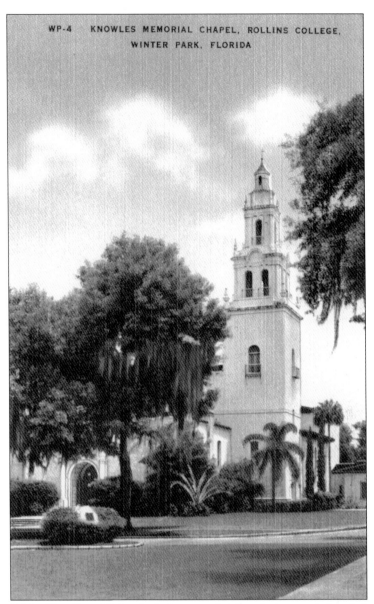

WP-4 KNOWLES MEMORIAL CHAPEL, ROLLINS COLLEGE, WINTER PARK, FLORIDA

In the early 1930s, Hamilton Holt asked the most famous designer of chapels in the United States, Ralph Adams Cram, to draw up a design for a chapel and theater complex at Rollins. Cram was the campus architect at MIT, Princeton, Boston University, and Wellesley (among others), and his designs were beautiful and timeless. The Knowles Memorial Chapel, funded by Frances Knowles Warren, the daughter of one of Winter Park's founders, became something marketers like to call the icon of Rollins College—the visual symbol people associate with the school. A garden and a covered walkway joined the chapel with the Annie Russell Theatre, a building funded by Mrs. Edward Bok, who was a friend of the retired British actress after whom the theater was named. (Russell had a home in Winter Park and taught theater at Rollins.) The complex was dedicated in 1932 and contained beautiful spaces in which groups from town and gown could take part in musical, spiritual, and artistic events. They quickly became integral to the relationship between Rollins College and the city.

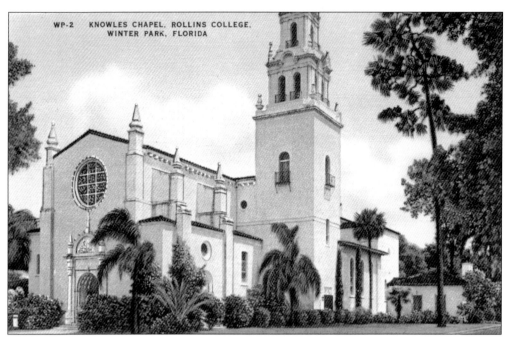

One local resident wrote of the Knowles Memorial Chapel, on this vintage card sent to a friend in New York, "This is said to be one of the most beautiful chapels in America, built by the architect Cram, who also built the chapel at Princeton. The open work tower against Florida blue sky is a landmark you come to love if you live here." What a lovely tribute to an architect's work.

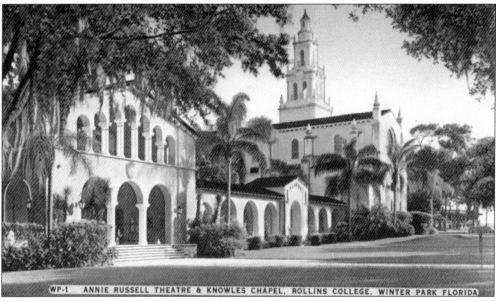

Actor Anthony Perkins trod the boards at the Annie Russell Theatre. He was at Rollins from 1950 to 1953, when he left to enter the movies. He starred in films with Gary Cooper and Jane Fonda, but he is best known for the role of Norman Bates in *Psycho*. After his death, his widow, Berry Berensen, continued to support Rollins until her own death on American Airlines Flight 11, September 11, 2001.

76

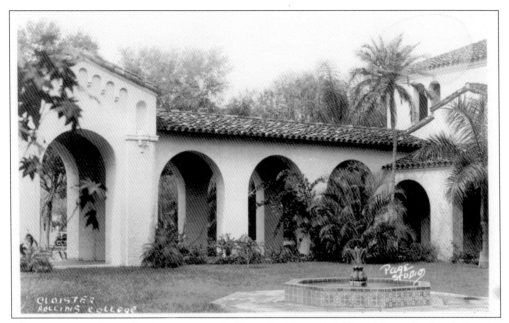

The sanctuary colonnade that separates the Knowles Memorial Chapel from the Annie Russell Theatre expresses the open-air theme Hamilton Holt favored for his college in the subtropics. On nights when there is a play at the theater, the garden becomes a place to spot pacing actors preparing to go on stage, and to see chatting audience members entr'actes.

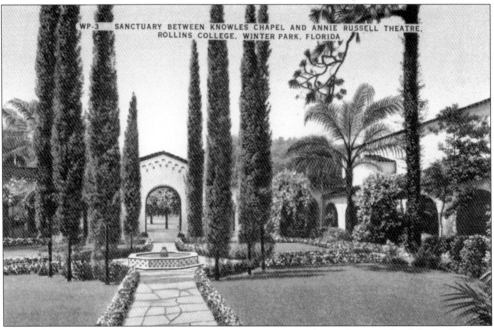

This postcard view of the garden between the two buildings shows the growth of the landscaping over the years, in contrast to the postcard view above. You can only imagine how many wedding parties have had their photographs taken in this space since the chapel was constructed. Ralph Cram created not only a lovely garden spot, but also a very practical one.

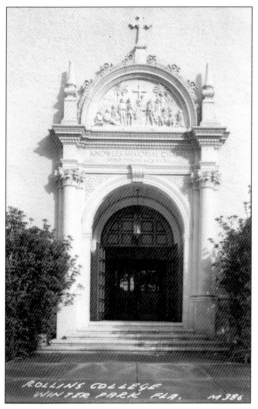

The style of the chapel is called American Transitional Neo-Gothic and is based on the design of 17th-century Spanish churches. The two vintage cards on this page show the west entrance and the beautiful bas-relief by William F. Ross and Co. of Spanish explorers planting the first cross on American soil. The Rose Window above the west entrance is surmounted by a banner that reads, "Wisdom Is Better Than Strength," always a good point to make at a college. When the sun is setting, its light shines through the window and creates a spectacular display inside the chapel. In the tower above, the college placed the bell from the original First Congregational Church in Winter Park, which first tolled Rollins students to class. There are more postcards of the Knowles Chapel (and a greater variety of them) than of any other structure in the city of Winter Park.

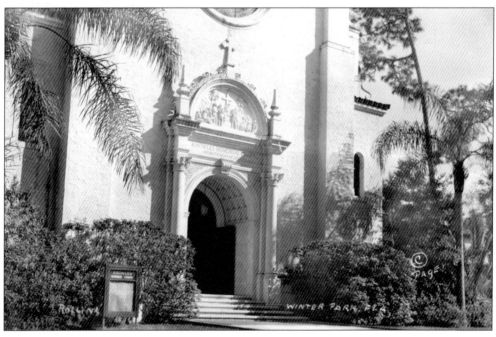

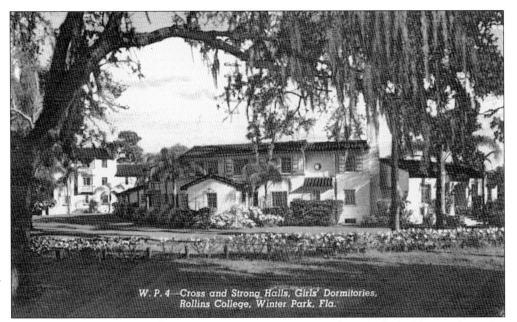

W. P. 4—*Cross and Strong Halls, Girls' Dormitories, Rollins College, Winter Park, Fla.*

One way construction was able to continue at Rollins during the Great Depression was through the government's Works Progress Administration (WPA). It provided funds for five buildings at Rollins in the 1930s: Hooker, Lyman, Gale, Cross, and Fox Halls. Strong Hall, shown on this postcard with Cross, was built in 1939.

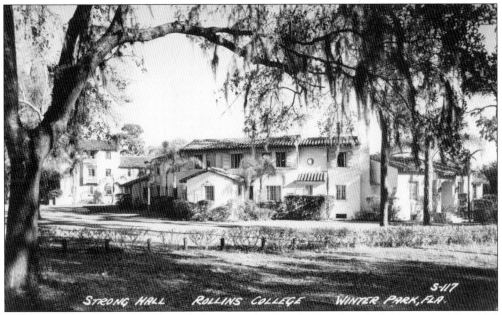

STRONG HALL ROLLINS COLLEGE WINTER PARK, FLA.

Architect Richard Kiehnel was once again responsible for the design of the new buildings. In spite of the fact that the decade of the 1930s was a difficult economic time for the country, Rollins College continued its steady growth. Holt was a canny promoter: in 1938 and 1939, he had honorary Rollins degrees conferred on Henry Luce, founder of *Time*; Adm. Richard Byrd, polar explorer; and Arthur Hayes Sultzberger, publisher of the *New York Times*.

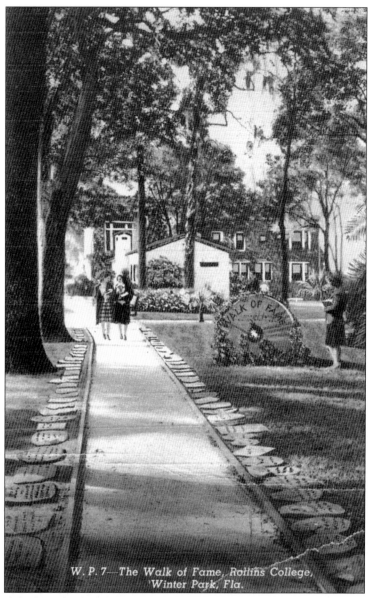

W. P. 7—The Walk of Fame, Rollins College,
Winter Park, Fla.

Hamilton Holt had another brainstorm in 1929 that became both a Rollins symbol and a college tradition: the Walk of Fame. It actually went back further than that to a path of stones at Holt's Connecticut home that he and his father had been collecting from around New England. When Holt came to Rollins, he and his wife decided to donate the collection—which had come from the homes of well-known Americans—to the college and enlarge it there. The Walk of Fame was dedicated on October 18, 1929, with 22 stones. As the years went by, some stones, such as those representing Presidents Franklin D. Roosevelt and Harry Truman, were dedicated with the famous on hand for the unveiling. Others, representing important figures from history, came from unusual places; the Dickens stone is a piece of flint picked up on the hill near the wooden cross Dickens placed over the grave of his pet canary.[6] By 1934, there were 372 stones on the path, and Rollins and Winter Park had another icon that became a favorite for those who made and sent postcards.

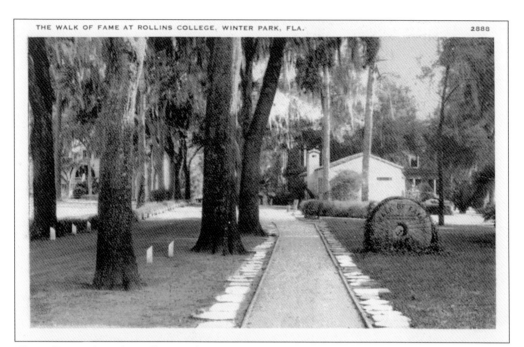

The millstone along the walk came from a historic mill near Holt's Connecticut home and is carved with the motto, "Sermons in stone and good in everything." The deal to get the stone to Rollins was certainly good; Holt paid two students returning to school $40 to haul it from Connecticut to Florida. It weighs more than 3,000 pounds, so they were paid .013 cents per pound.

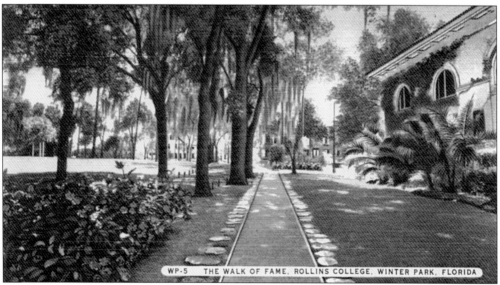

WP-5 THE WALK OF FAME, ROLLINS COLLEGE, WINTER PARK, FLORIDA

In 1945, someone donated a stone from the bunker fireplace of Adolph Hitler to the Walk of Fame. There was much controversy, but Holt accepted it saying he had long thought there should be a Walk of Ill-Fame to include, in his words, "Benedict Arnold, Madame de Pompadour, Hitler, Mussolini, and President Harding."[7] It wasn't a popular idea, and the Hitler stone vanished. Why Holt put Warren G. Harding in the same category as the Führer is something only he could tell us.

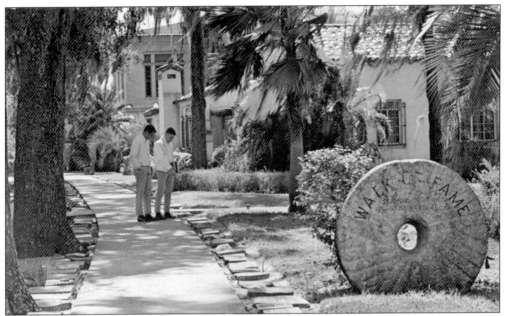

"Greetings from the Sunshine State!" writes the sender of this card. "It was a relief to leave snow and ice. . . . I'm storing up all the warmth I can to take me over until summer reaches Ohio." The writer then adds, "Last week was Founders Anniversary and we enjoyed the activities." It was during Founders Week that Holt held his Animated Magazine.

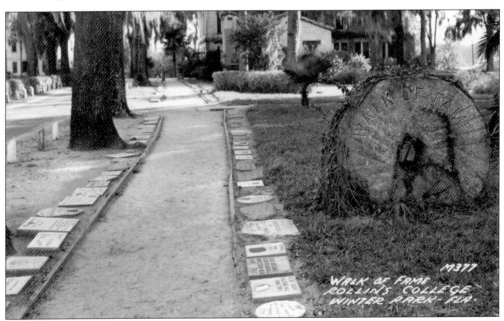

After Hamilton Holt retired in 1949, the Walk of Fame lost its champion. Golf carts, bicycles, decades of feet, college pranks, and the weather took their toll. In 1980, Rollins president Thaddeus Seymour arranged to have the walk re-landscaped and the stones catalogued and conserved. Now the walk, with its stones representing the famous from John Adams to Zacchaeus, remains for the enjoyment of future generations.

82

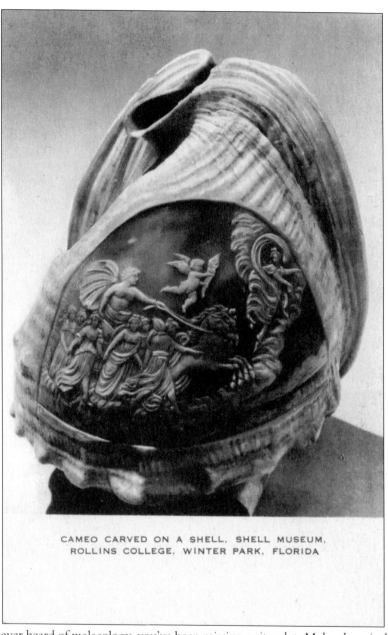

CAMEO CARVED ON A SHELL, SHELL MUSEUM, ROLLINS COLLEGE, WINTER PARK, FLORIDA

If you've never heard of malacology, you've been missing quite a lot. Malacology is the study of mollusks—creatures that live in shells. Dr. James Hartley Beal (1861–1945) was a malacologist who lived part of the time on Florida's Merritt Island, and in the course of his life, he gathered a formidable collection of seashells. In 1940, he donated his collection to Rollins College, and B. L. Maltbie, sometime mayor of Altamonte Springs, agreed to supply the funds for a building to hold the collection. The result was the Beal-Maltbie Shell Museum at Rollins, housed in a small building on Holt Avenue, west of the horseshoe and just across from the athletic field. Since Florida is a peninsula between two large bodies of water that contain millions of shells, the museum captured the imaginations of visitors, especially visitors from places not so near the ocean. This cameo carved into a shell was of interest to visitors and malacologists alike.

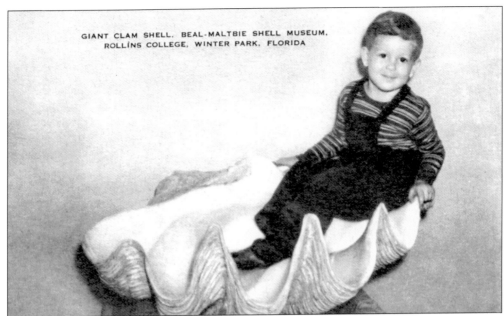

GIANT CLAM SHELL. BEAL-MALTBIE SHELL MUSEUM,
ROLLINS COLLEGE, WINTER PARK, FLORIDA

Kids love shells, and this one that was bigger than a child was always a hit at the Beal-Maltbie Shell Museum. From the boy's clothing, the photo appears to be from the 1950s, but even after a public search that took place with the help of the *Orlando Sentinel*, we haven't learned the name of the pixie on the half shell.

W. P. 5—The Beal-Maltbie Shell Museum
Rollins College, Winter Park, Fla.

The museum, which cost about $10,000, was one of the few buildings constructed during the tenure of Hamilton Holt (other than the chapel) that was not designed by Kiehnel. Harold Hair was the architect and contractor; H. C. Cone handled the construction. Together, the two continued the Mediterranean style used in the other new structures on campus, and the museum was a pleasing addition to the growing beauty of the school.

84

The proper display of the collection, its hours of operation, and the conservation of the shells became issues as the years went by, and in 1988, the Beal collection was donated to the University of Florida. The museum was closed, but the pretty little building is still in use at Rollins as offices for the Department of Environmental Studies.

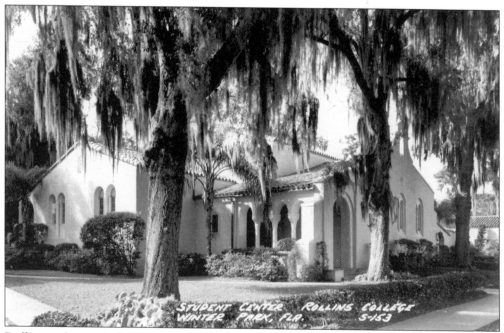

Rollins students raised some of the money for the Alumni House and Student Center, which was built in 1941, a transition year of great importance. War had broken out in Europe in 1939, and the school term of 1940–1941 was the last one before America, too, joined the war. It was also the last year in which new buildings were constructed until the war ended nearly five years later.

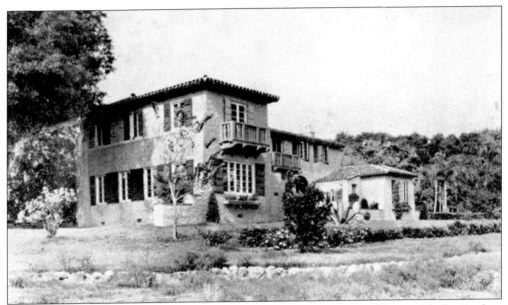

The French House was a gift to the school from Mrs. Homer Gage. Along with the Student Center and the Beal-Maltbie Shell Museum, it was one of the final buildings dedicated before the U.S. entry into World War II. In this postcard, the grounds aren't looking particularly good—unusual at Rollins. Perhaps the photo was taken shortly after construction.

Rollins had a world-class tennis player on its courts in the early 1940s in student Pauline Betz, who in 1942 was named State Amateur Tennis Champion. The war made international play impossible, and it wasn't until 1946, when she was 27, that Betz was able to take the skills learned on the Rollins courts to the Wimbledon Championships. She won the ladies' singles title there in 30 minutes (6-2, 6-4), without losing a set.

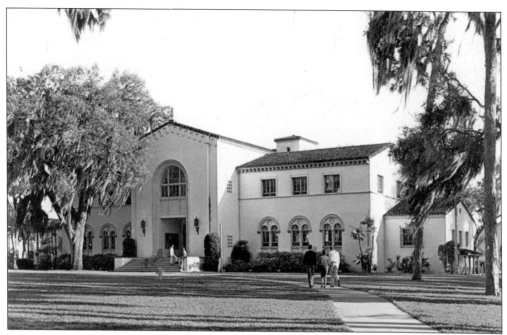

Richard Kiehnel died in 1942, and George Spohn of Kiehnel's firm took on the role of campus architect. James Gamble Rogers II—whose fame had been growing steadily—was asked to work with Spohn on the design for a new library. It would be Hamilton Holt's final architectural contribution to the school.

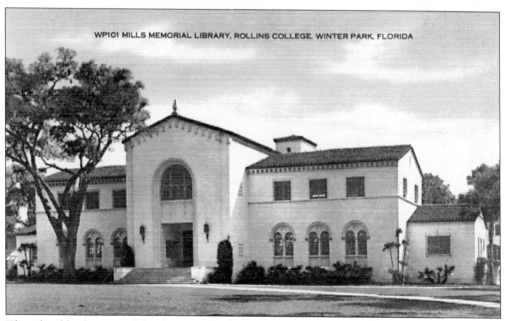

WP101 MILLS MEMORIAL LIBRARY, ROLLINS COLLEGE, WINTER PARK, FLORIDA

The school broke ground for the new library in 1949, the same year that Hamilton Holt retired. The building cost $500,000, was funded by the Davella Mills Foundation, and hence, became the Mills Memorial Library. The building was dedicated in 1951.

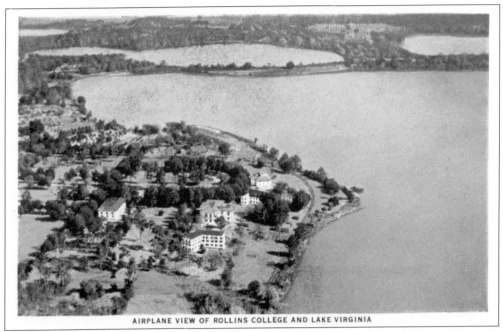

AIRPLANE VIEW OF ROLLINS COLLEGE AND LAKE VIRGINIA

It was in 1925 that Hamilton Holt began his tenure as president of Rollins. Then, the school's entire assets were valued at $855,419.49. There were just six main buildings. Seventeen students graduated that year. This postcard view shows the tiny campus of Rollins College in the 1920s.

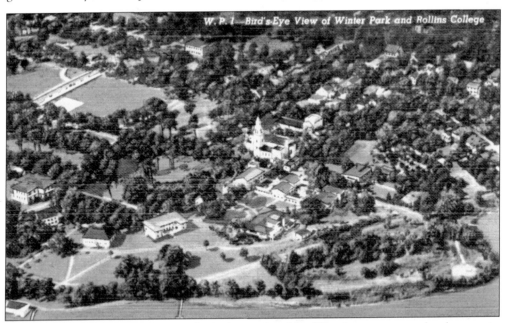

Hamilton Holt added 32 buildings and raised more than $5 million for programs and endowments. But more than that, he was the first person to see Rollins as a world-class school and to make his vision a reality. Not everyone agreed with his strong opinions; however, by force of will during his quarter-of-a-century as president, he transformed Rollins into an internationally known institution. As it turns out, those same years had also been transforming Winter Park.

Six

WINTER PARK GROWS UP

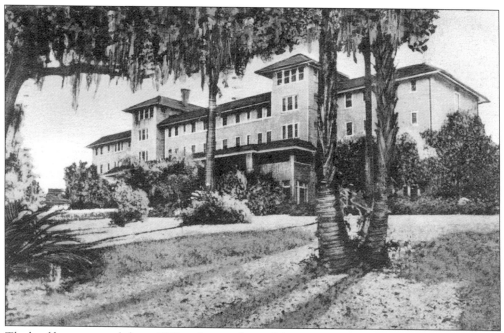

The land boom started about 1920 and swept through Winter Park like a category five hurricane. In 1920, the total value of building permits issued by the city was $115,450; in 1923, it was $243,000. By 1926, the figure had zoomed to $1.8 million. One of the biggest projects was the Alabama Hotel, opened in 1922. The first three large hotels in Winter Park had faced onto Lake Osceola; the Alabama was the first on Lake Maitland.

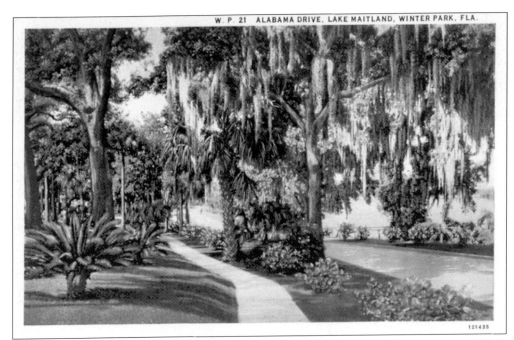

121435

The Alabama was named for the estate land on which it was built. In 1898, citrus grower W. C. Temple came to Winter Park and bought what historian Claire Leavitt MacDowell identifies as "the Alabama property."[1] In 1920, the land was sold to a real-estate developer from Cleveland.

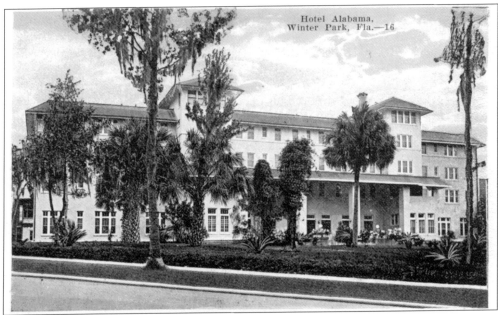

Hotel Alabama, Winter Park, Fla.—16

Though some of the groves were destroyed for the hotel's construction, many of the trees were preserved for both their beauty and their practicality. The Alabama took advantage of their presence and advertised, "A carefully planned cuisine is supplemented by the groves of the Alabama, which afford an abundant supply of tree-ripened oranges, grapefruit, papayas, kumquats, guavas and other delicious fruit."

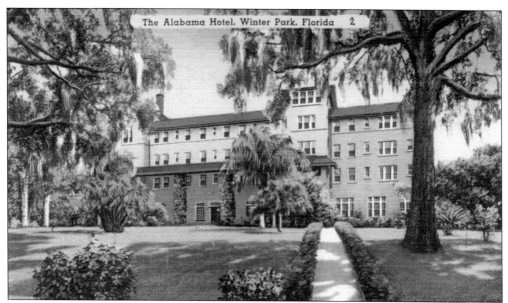

Calling itself "one of the most delightful resorts in the South," the Alabama told its patrons the hotel provided "a fascinating tropical setting for a widely diversified social life." When visitors arrived by train, they were greeted by bellmen with letters of introduction. Their luggage was taken care of, and they were whisked by limousine to the hotel. This card was sent to a prospective guest saying, "Can we quote you rates for a visit?"

415 A BEAUTIFUL FLORIDA SCENE. AZALEAS, LIVE OAKS AND SPANISH MOSS

One of the many benefits of the boom was that the city of Winter Park now had more tax revenue to spend on beautification, and in 1926, the city set aside $10,000 to develop a park on the south shore of Lake Maitland near the Alabama Hotel. This is the property that eventually became the George Kraft Memorial Azalea Gardens on Alabama Drive.

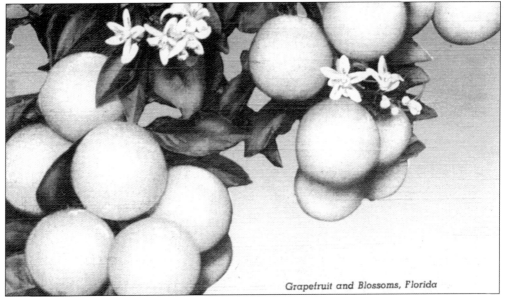

Grapefruit and Blossoms, Florida

Nineteen twenty was a good year for Winter Park citrus. Grapefruit prices were up, and the demand for them in the North was growing. Temple oranges hit a record price of $27 a box. The original Temple orange tree was preserved on Temple Grove Drive and labeled the "orange tree that made Winter Park Famous."[2] (Courtesy of the Florida State Archives.)

Orchids from Florida

A group of women established the Winter Park Garden Club in 1922, and that same year they held Florida's first flower show. The Winter Park Garden Club is also credited with helping to establish the Florida Federation of Garden Clubs by providing the first $5 donation to get it going, which was "the nucleus from which has grown our splendid gifts to the world of beauty."[3] (Courtesy of the Winter Park Public Library.)

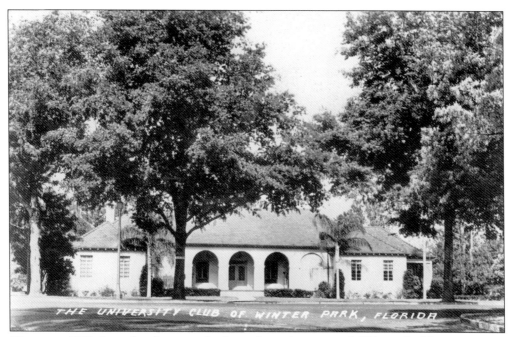

The year 1923 brought the organization of another one of Winter Park's most active organizations—the University Club of Winter Park. The club was originally for men only, with the writer Irving Bacheller serving on the original board of directors. The popular club now has many women members and officers.

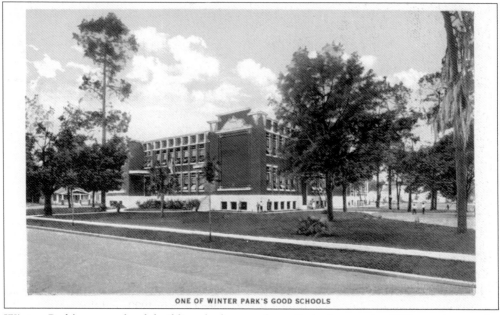

ONE OF WINTER PARK'S GOOD SCHOOLS

Winter Park's new school building had opened on Park Avenue in 1917, serving grades 1 through 11, with 150 students on hand taught by 11 teachers. Plans were made to add a 12th grade if it appeared the town wanted one. The boom brought more students, so in January 1923, the city dedicated its new high school.

Thirty-five subdivisions were planned in Winter Park just for the year 1925. In that year, $12 million worth of real estate changed hands. Carl Dann, who later developed Dubsdread County Club, bought some of the Comstock estate acreage and subdivided it into 325 building lots. (Courtesy of the Winter Park Public Library.)

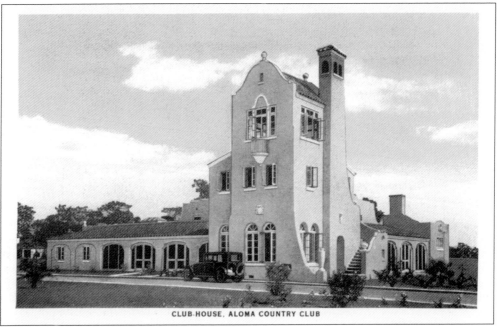

CLUB-HOUSE, ALOMA COUNTRY CLUB

The Aloma Country Club opened in the 1920s on the southeast corner of what is now Aloma and Lakemont—the site that later became home to the Winter Park Hospital. The club had an 18-hole golf course of 6,180 yards.

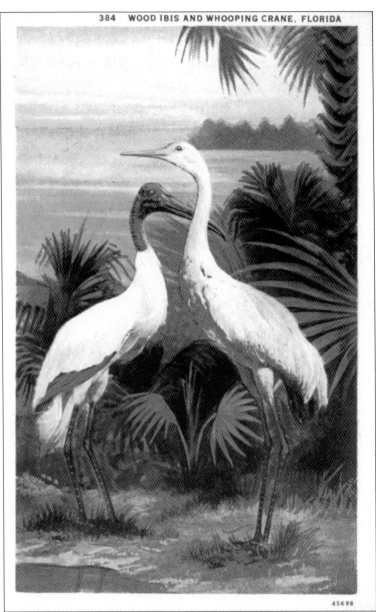

45698

Some of Florida's exotic wildlife paid a price during the uncontrolled development of the 1920s. When estuaries were drained, aquatic birds lost their fishing grounds. Others had been hunted for years for their feathers, which were worn in women's hats or sold to tourists. It is sad that this happened, but it happened almost entirely through ignorance. The whooping crane, shown here, once spent its winters in Florida's wetlands; however, by 1937, there were only 20 pairs remaining in the entire United States. They are slowly being reintroduced into the wild today with mixed success. The wood ibis shown on this card—also known as the wood stork—is on the endangered species list, though you can still spot them in and around Winter Park's lakes. The sender of this card wrote, "I have not seen these birds—they do not seem common, but must be native here. I like the flamingoes better, but they are imported." She was correct on all counts. (Author's collection.)

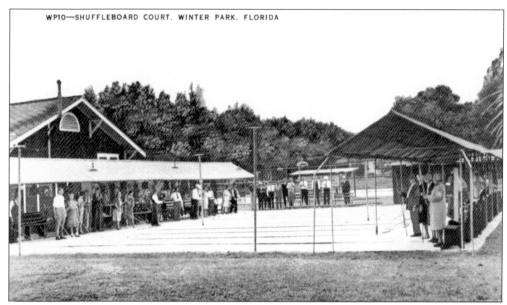

The city continued its spending on parks, setting aside $5,000 in 1924 to install a recreation field on Park Avenue that included shuffleboard courts. Later, the city of Winter Park turned over maintenance of the courts to the Shuffleboard Club. The town of Winter Park was growing at such a rate that in 1923 it took the official steps necessary to become a city.

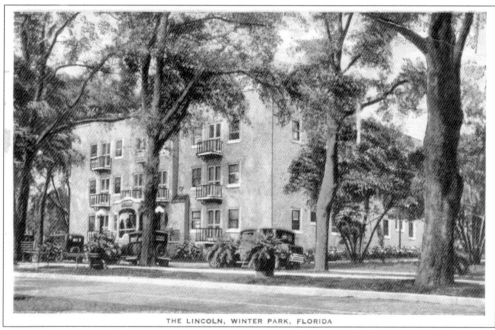

The Lincoln Inn & Apartments went up on the Boulevard (now Morse Boulevard) from 1925 to 1926, but not before the land on which it was built played a role in the wild speculations going on at the time. Dr. R. F. Hotard bought the Lincoln Inn lots in April 1925 and sold them a few months later for $12,000. He then repurchased them for $18,000, and in August resold them for $25,000.[4]

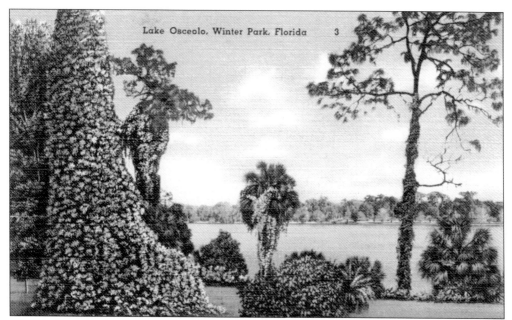

The city also allocated dollars to deepen the canals between Lake Maitland and Lake Osceola and between Lake Osceola and Lake Virginia. The U.S. Government Fish Commission cheered local fishermen by putting 30 gallons of black bass minnows into Winter Park's lakes. Note the misspelling on this vintage card of Lake Osceola.

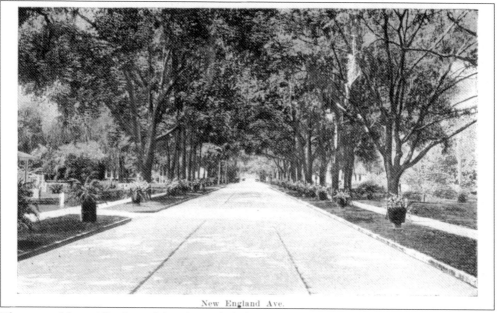

New England Ave.

The general beautification of the city included Winter Park's streets, as this postcard of New England Avenue looking west shows. The trolley tracks were removed from New England in 1903, after the Seminole Hotel fire, but it appears remnants of them can still be seen. About this time, Winter Park passed a new ordinance prohibiting bonfires on the new brick streets. No more hot times in the old town.

The ubiquitous Irving Bacheller preached the first sermon in the new Methodist church, which was dedicated in May 1923. The old church, built in 1896, had survived at least one fire and was torn down in 1922 to make way for the new building.

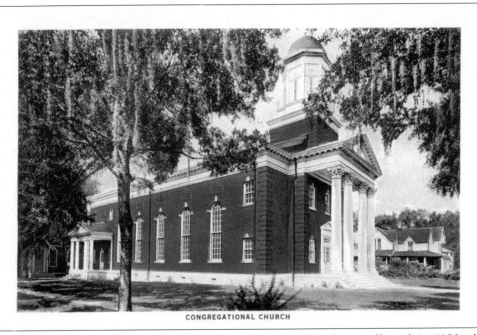

CONGREGATIONAL CHURCH

Plans got underway in 1920 for a new Congregational church as well, and in 1923, the parishioners laid the cornerstone for the new building. In January 1925, the church dedicated its new $100,000 sanctuary on a site adjacent to its old building that had been donated by the late C. H. Morse. His daughter, Elizabeth Morse Genius, gave the church its organ and chimes.

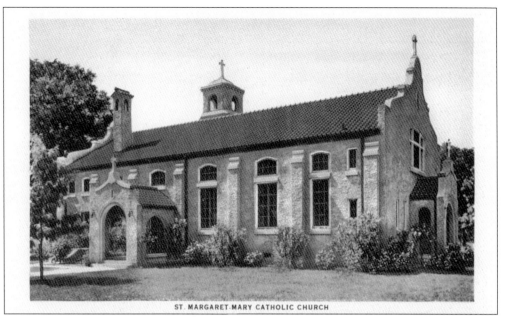

ST. MARGARET-MARY CATHOLIC CHURCH

In 1925, 50 local parishioners attended the first mass at the St. Margaret Mary Catholic mission church, celebrated by Rev. Michael Fox. By 1927, Reverend Father Mockler of Marquette, Michigan, was installed as the resident priest, and the church's first stained-glass window was designed and dedicated.

A. C. L. Depot, Winter Park, Fla.

At the depot in Winter Park, travelers could send telegrams from the new Western Union window. But Tampa and Miami were growing even faster than Winter Park. In 1922, Winter Park's commissioners appealed to the Atlantic Coast Line to have the *Tampa Special* make regular stops in Winter Park. As one visitor wrote, "The train Tampa Special doesn't stop in Winter Park. I went to Orlando on it and motored back." That can't have been good for business.

The Florida Seminole took steps in the 1920s to join in Florida's growing prosperity. The few who had remained in Florida after the end of the Seminole Wars had never signed a treaty of peace with the United States government. In 1926, their chief wrote President Coolidge and offered to settle up.[5] The Seminole were granted their treaty and later their own reservation land. (Author's collection.)

INTERLACHEN

Two hurricanes hit Florida in 1926. One struck Miami in September with winds of 138 miles per hour. It was so powerful that it actually swept people off the ground. A smaller hurricane came ashore and blew through Winter Park with winds of 90 miles per hour.[6] As one local wrote, "It uprooted large oaks . . . and demoralized the light and telephone service."[7] In the 2004 hurricane season, Winter Park residents came to understand what demoralized really means. (Courtesy of the Florida State Archives.)

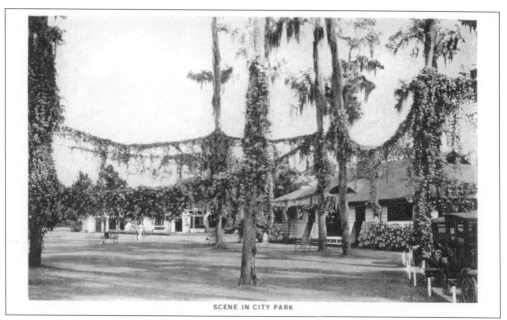

SCENE IN CITY PARK

The first sign that the land bubble was beginning to burst came in 1927. The value of building permits, which had reached almost $1.8 million in 1926, dropped to $725,000 in 1927 and then to $167,000 in 1928. The city was unable to make its annual payment to the estate of C. H. Morse for the use of the Winter Park Country Club land.

Boulevard, Looking East from R. R. Station.

City streets grew quieter as the end of Florida's boom dissolved into the nation's Great Depression. Another deadly hurricane, which took more than 2,000 lives in Belle Glade and Pahoke, Florida, in 1928, added to the gloom. For many years after the boom went bust, sidewalks that had been installed in subdivisions that were never built could be seen throughout the state.

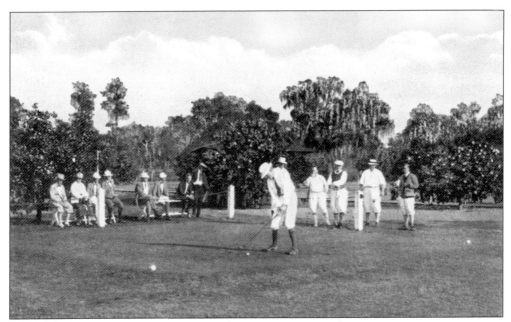

It may have had more to do with economics than with changing mores that caused Winter Park, in 1929, to approve Sunday baseball, golf, tennis, and movies. In earlier decades, students at Rollins College could be expelled for boating on Sunday, but with a depression looming, what was good for business was now less likely to offend Winter Park's many churchgoers. (Courtesy of the Florida State Archives.)

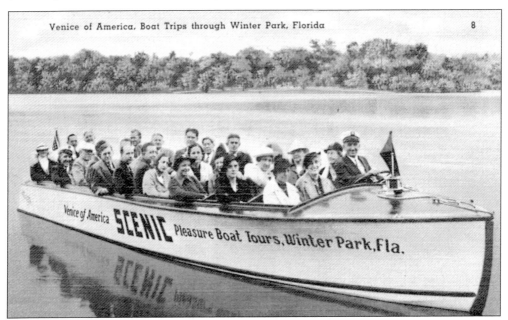

Economic hard times didn't stop entrepreneurs like Capt. Walt Meloon of the Pinecastle Boat Company. He began operating his tour boat, the *Scenic*, on Winter Park's chain of lakes in 1937. The boat had a capacity of 35 and took passengers through Lakes Maitland, Osceola, and Virginia on a two-hour tour. At least it wasn't a three-hour tour.

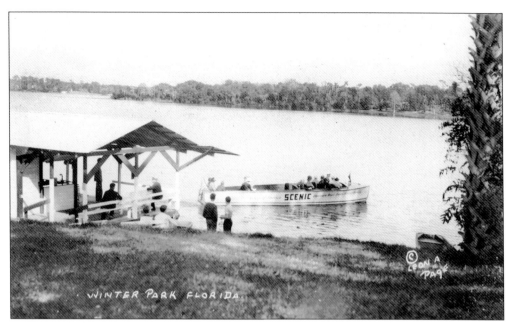

This is another vintage card that shows the *Scenic* as it departs from the dock at the end of Morse Boulevard. By the 1930s, Winter Park was again looking for ways to encourage tourism and development, and this tour boat attraction is one that has endured. In fact, it is the only business still operating on any of Winter Park's lakes.

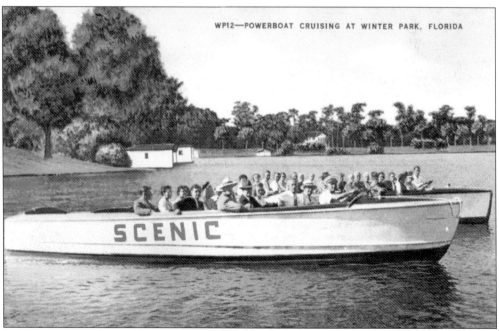

Captain Meloon ran the Winter Park Scenic Boat Tour from its beginnings until 1959, when he sold the business to Bob Buhrows. Since then, the Bout Tour (as it is affectionately known in Winter Park) has had only four other owners. The boats changed from the style you see here to pontoon boats after 1981.

A resident named John H. Connery first promoted the idea of a garden in Winter Park honoring botanist Dr. Theodore L. Mead. In 1937, Connery found a suitable 55-acre tract of land for the project on the edge of Winter Park, and the WPA contributed $62,170 to the work of preparing Mead Botanical Garden.

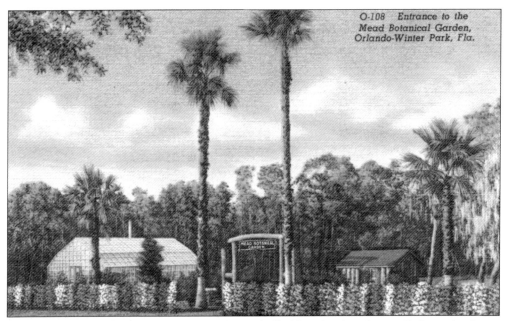

Dr. Theodore Mead (1852–1936) was a Central Florida scientist who studied exotic plants, and when Mead Botanical Garden was established, his family donated his collection of orchids to Winter Park. The garden sits between Orlando and Winter Park. Orlando residents like to point out that the entrance is in Orlando. Winter Park residents like to reply (with a smile, of course) that all of the acreage except the entrance is in Winter Park.

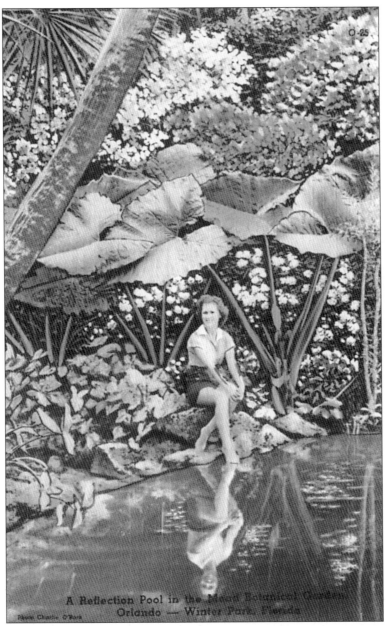

A Reflection Pool in the Mead Botanical Garden
Orlando — Winter Park, Florida

Without the help of the WPA, Mead Botanical Garden would not have become a reality, but with the government's help, the park was able to open two miles of paths by 1939. The Winter Park Garden Club designed and donated a calla lily garden and held a camellia show there as well.[8] Neither the city, nor the WPA, nor the Garden Club planned for the resources required to maintain this complex botanical garden in a climate like Central Florida's, in which weeds, vines, and other volunteer plants spring up overnight. The difficulties of keeping the park pruned and tidy have, consequently, been enormous over the years on the 55 acres. By the 21st century, there was much to be done to return the park to the state that was promoted in these vintage cards. A group called the Friends of Mead Garden was organized in 2004 to promote the park's cleanup and to ensure its future.

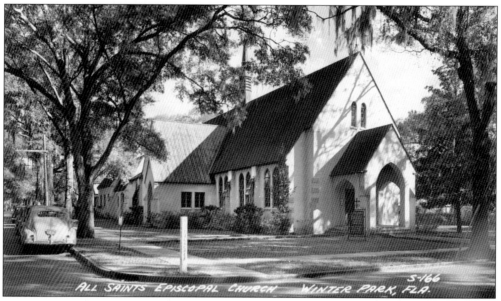

The members of All Saints Episcopal Church liked what they saw in Ralph Adams Cram's design for the Knowles Memorial Chapel at Rollins. The church hired Cram to design their new church. The original building was razed, and the charming new church was constructed and is now on the National Register of Historic Places. In the sacristy, you can still see a beautiful window from the old church, dedicated by diarist Mary Brown in 1891 to her missionary father.

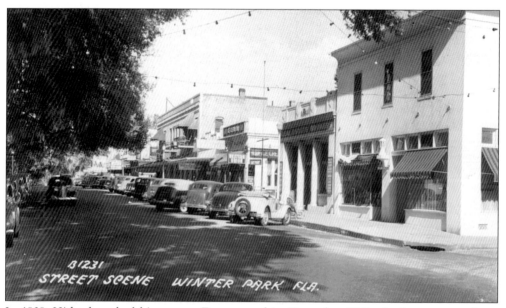

In 1939, Hitler launched his war on Europe, and in December 1941, the Japanese attack on Pearl Harbor brought America into the biggest world war in history. For the duration, almost nothing civilian was built—industry was too busy building planes and tanks, and supplies simply weren't available. In this vintage card of Park Avenue, it does appear somebody at least found some Christmas lights to brighten the holiday season.

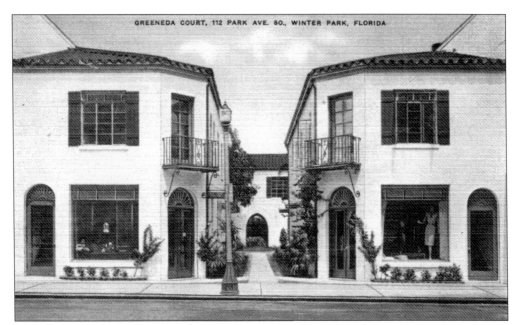

Dreams, however, were not set aside for the duration. Longtime resident and one-time mayor Ray Greene and his friend James Gamble Rogers II spent time during the war imagining the kind of building they would construct when the war was over. What they had in mind was the mixed-use Park Avenue building that would one day become Greeneda Court.

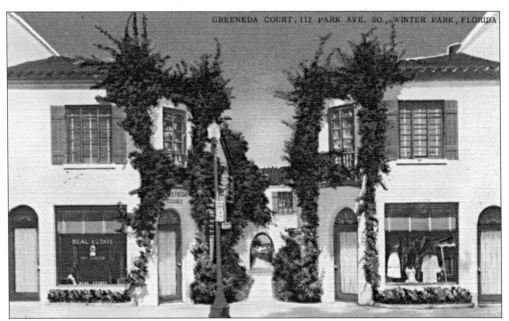

Beginning in 1945, Rogers designed for Greene two narrow buildings that included both small apartments and shops, joined by a courtyard. This postcard view of Greeneda Court, with its landscape slightly altered from the one above, was in a box of cards uncovered just a few years ago during a tenant's renovation. The beautiful structure, now a Park Avenue fixture, "turned an otherwise ordinary commercial commission into one of Park Avenue's most alluring spaces."[9]

107

This postcard, showing the veranda of the Alabama Hotel, somehow ended up in the hands of a sailor who mailed it from California to his parents in Pennsylvania. Perhaps he picked it up while stationed at the Orlando Naval Training Center, which was just outside Winter Park. "Some quiet today," he writes. "Some celebrating last night." The card is postmarked August 15, 1945—VJ day—the day that marked the end of World War II.

World War II changed life forever in Florida. Soldiers and airmen who had trained in the state's mild climate came back to her schools, where they studied on the GI Bill, and married their sweethearts. The decades ahead brought air-conditioning and theme parks to Central Florida, and unimaginable growth. Still, the outlines of Winter Park changed little. It would always remain the Florida city designed to be just like home—but with much better weather.

Seven

WHATEVER HAPPENED?

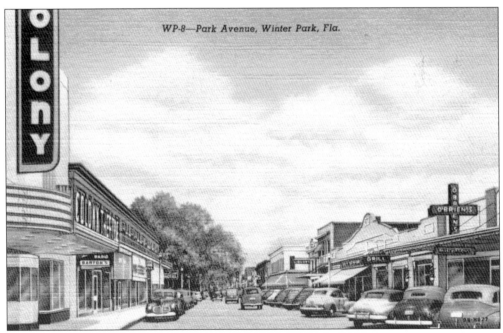

WP-8—Park Avenue, Winter Park, Fla.

Winter Park has survived more than a century of change because its founders created a very good plan for the city. Though the horses and buggies on Park Avenue have been transformed into automobiles, the avenue continues to serve as Winter Park's central business district. The Colony Theater doesn't run movies anymore, but the newest tenants preserved its marquee. The street, once paved in brick, then repaved in asphalt, is brick again after a turn-of-the-21st-century renovation. As for the rest of the city—let's look around and find out what happened.

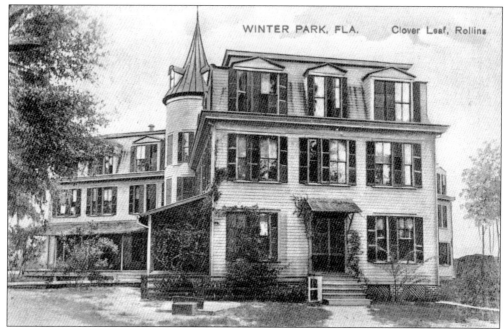

One of the most architecturally interesting of the early buildings at Rollins College was Cloverleaf Cottage, built in 1890. (Though it is spelled as two words on this vintage card, it was more commonly spelled as one.) Cloverleaf served Rollins long and well. In 1969, it fell to the wrecking ball, replaced by a new dormitory, George Morgan Ward Hall.[1]

Pinehurst is the only original 19th-century Rollins building to survive into the 21st century. Built in 1886 and situated on the east side of the Rollins horseshoe, the building began life as a girls' dormitory. Today it serves as a campus residence club, with 24 rooms for students who must apply for a place in the venerable dorm.

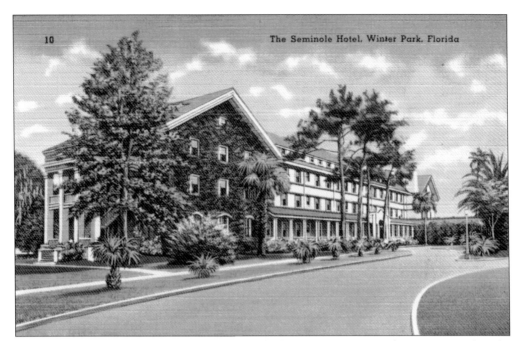

The New Seminole Hotel, opened in 1913, had a long run. Writer Sinclair Lewis stayed at the New Seminole in its heyday and probably enjoyed one of the hotel's famous 11-course dinners. In the 1960s, the city nixed a plan to build condominiums on the site, and in 1970, the hotel was sold and demolished. The houses of Kiwi Circle are located where the old hotel once stood.[2]

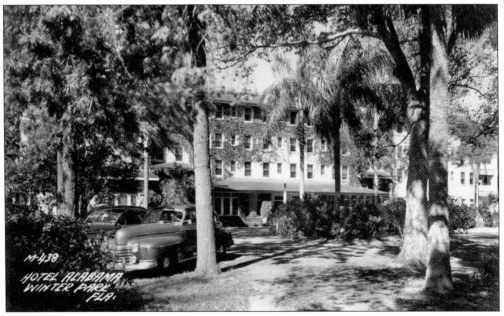

If you take Alabama Drive off Palmer Avenue today, you'll see the Alabama on the crest of the hill above Lake Maitland, looking much as it did when it opened for business in 1922. In 1960, it was converted into a retirement hotel, and in 1979, it was closed for a renovation. When it opened again in 1981, it opened as the Alabama Condominiums, which it continues to be today.

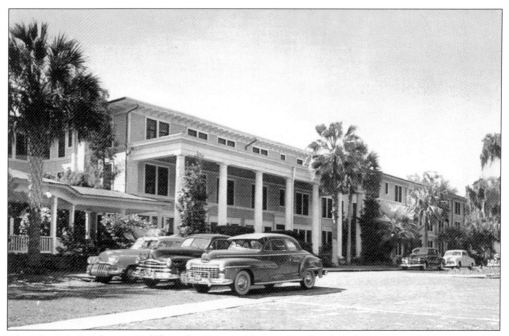

The Virginia Inn began its life as the Rogers House, the first hotel in Winter Park, opened in 1882. The name of the inn was changed several times until it became the Virginia Inn, a name it kept for 60 years. In 1966, the aging hotel sold for $235,000 and was demolished to make way for the construction of the Cloisters Condominiums.[3]

FLORIDA'S FIRST "Make Your Own Sundae" Ice Cream Parlor

Lots of Winter Park adults remember going to the Yum Yum Shoppe when they were children. The little restaurant at 252 North Park Avenue served sandwiches and snacks in addition to being the home of—as the vintage card above points out—"Florida's First Make Your Own Sundae." It has gone the way of the nickel telephone call; in its place you'll find the Briarpatch Restaurant.

The Langford Hotel opened in 1956 and had two very popular features: a swimming pool locals could use if they joined it as members and a bar that immediately became a local hangout. Located just off Park Avenue, at the corner of New England and Interlachen, it was Winter Park's hippest post–World War II hotel.

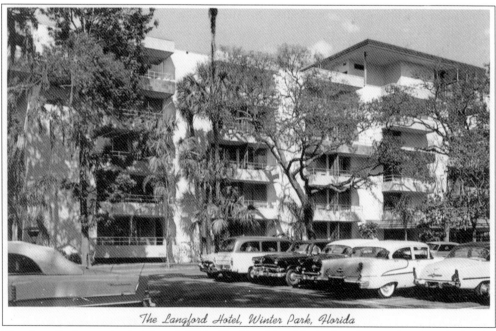

The Langford Hotel, Winter Park, Florida

The Langford was the height of 1950s Florida chic; faintly flamingo-colored, it had palm trees and a tiki bar decor. Ray Charles stayed at the Langford and so did Bob Dylan, Charlton Heston, Mamie Eisenhower, and Ronald and Nancy Reagan. The Langford closed on May 30, 2000, and its owner, Robert Langford, died the next year.[4] It was razed, and the new Regent Orlando at Winter Park Hotel went up on the site.

City Hall, Winter Park, Florida

Here is a Park Avenue building that makes some long for the old shuffleboard courts that used to be in this spot. This postcard doesn't do Winter Park's 1962 City Hall justice; you really have to see it in person to be properly impressed. The good news it is now far too small for the city's needs, and in 2004, officials began discussing plans to tear it down and build a replacement.

SCL DEPOT WINTER PARK, FLA. 1979

Winter Park's 1960s train depot looks like a relative of city hall. It has a lobby that in summer is kept as cold as a meat locker. Inside, there is a really nice oil painting of a previous depot. There was a proposal to replace this one with a charming building to be shared with the chamber of commerce, but the plan was voted down.

The peacock is not native to Florida, but Winter Park often uses it on city symbols. That is because the granddaughter of Charles H. Morse, Jeannette Morse Genius McKean, introduced them onto her Genius Drive estate, where they prospered. She and her husband, Hugh McKean (one-time president of Rollins College), left rural Genius Drive open so that people could stroll among the citrus groves and enjoy the beautiful peacocks. Alas, someone killed a few of the birds, and the road was closed off except for special events. Now part of the Windsong subdivision and its adjacent preserve, Genius Drive still has some peacocks, and if you are out on Lake Virginia, near the Windsong property, you can hear their loud, haunting calls. If you've ever had to live around these unpleasant creatures, you may understand why somebody once bumped off a couple of them.

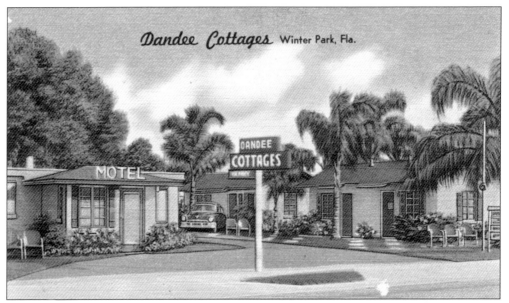

Winter Park's Dandee Cottages could once be found at 130 North Orlando Avenue (Route 17-92). Owned and operated by Mr. and Mrs. Edward Wittman, the cottages had rooms that were "insulated for year 'round comfort" and included "panelray heat." If you are looking for them today, you won't find them; a Midas Muffler shop sits where the Dandee once stood. Blighted 17-92 could certainly use something this dandy today.

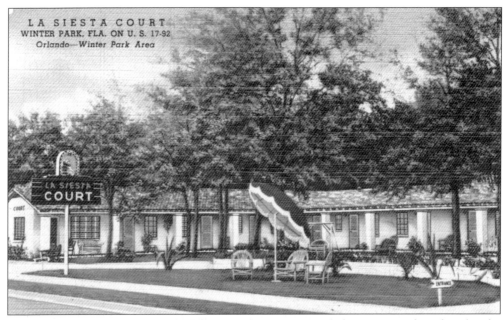

La Siesta Court looks like it could deliver on the promise made by its name, though today the traffic passing by 325 South Orlando Avenue might make repose a little rocky. It was advertised as being "in the heart of the Million Dollar Court Area" and promised (like Ray Charles at the Langford?) it was "always cool." You can actually see the building today on Route 17-92, but it is now called the Ranch Mall and contains the popular Black Bean Deli.

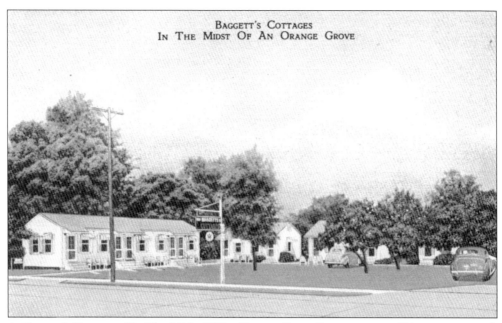

BAGGETT'S COTTAGES
IN THE MIDST OF AN ORANGE GROVE

At Baggett's Cottages, "In The Midst Of An Orange Grove," guests were told it was very much okay to pick an orange from a nearby tree. Located at 848 South Orlando Avenue, its owners advertised that its cottages were "modern in every respect." But the world grew too modern for Baggett's, and both the motel and the orange groves around it are gone. In the location today you'll find a Steak & Shake.

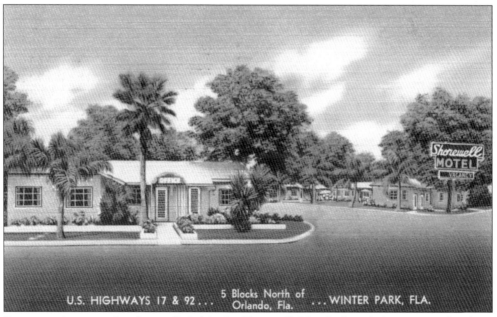

U.S. HIGHWAYS 17 & 92 ... 5 Blocks North of Orlando, Fla. ... WINTER PARK, FLA.

I'm not quite sure why they called this the Shorewell Motel, since it is not near the shore of anything. At 640 South Orlando Avenue, the Shorewell's owners promoted its in-room telephones and televisions and its "cross ventilation" and "air conditioning optional." Its options ran out; in its place today you'll find a Subway and a Taco Bell.

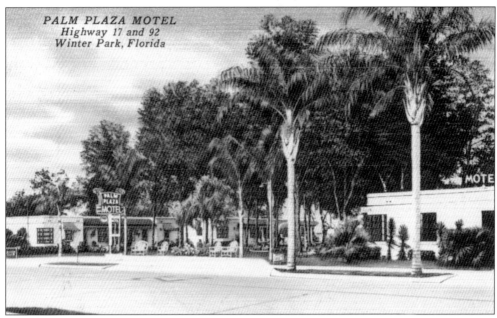

PALM PLAZA MOTEL
Highway 17 and 92
Winter Park, Florida

Mr. and Mrs. C. R. Hurley owned and managed the Palm Plaza Motel at 459 South Orlando Avenue. You could choose from an air-conditioned or a cross-ventilated room (hmm, which to choose?) and from overnight or weekly rates, and you would find "convenient parking at rear doors." The palms and the motel are very inconvenient today—replaced by a Wendy's.

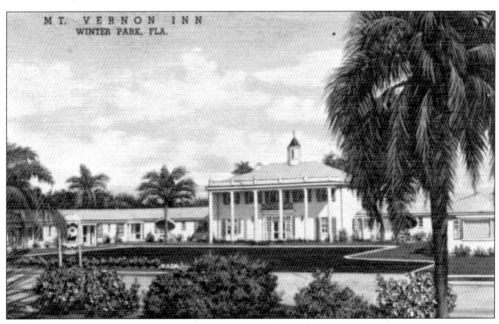

MT. VERNON INN
WINTER PARK, FLA.

Here's a surprise: a nice hotel-motel that survived into the 21st century. Located at 110 South Orlando Avenue, the Mt. Vernon Inn was owned and operated in the early 1950s by L. V. Bledsoe, who used the improbable motto "Travel 1st Class—It Costs No More." Later operated by the Frazees, it is now run by Rick Frazee, an avid collector of both Winter Park postcards and classic British motorcars.

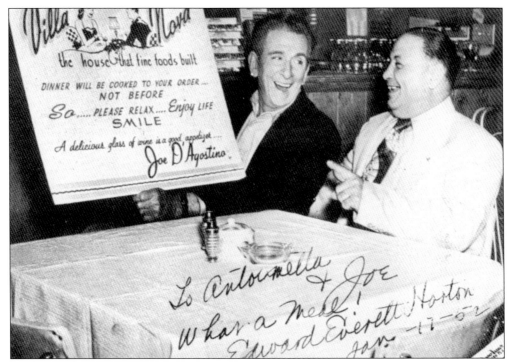

Villa Nova Restaurant opened in 1948 at 839 North Orlando Avenue in Winter Park. In this 1952 postcard, actor Edward Everett Horton clowns it up with owner Joe D'Agostino. The D'Agostinos ran the restaurant as a family project and had this notice on the wall: "Dinner will be cooked to your order, not before. So please relax, enjoy life, and smile. A delicious glass of wine is a good appetizer."

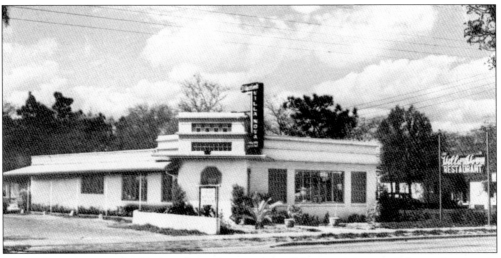

Mrs. D'Agostino ran the kitchen from the opening of the restaurant until her retirement in 1961. Except for one year, when the family sold the restaurant only to buy it back again, family members kept the Villa Nova going until 1981.[5] After that, the restaurant continued under other owners until 1990. Today, on the site where so many relaxed, enjoyed life, had a glass of wine, and smiled, you'll find a CVS Pharmacy.

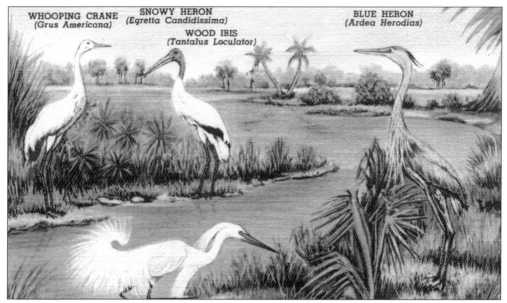

Many birds are now protected in Florida. The whooping crane is being reintroduced, and you'll see the wood ibis in Winter Park. The great blue heron has become (almost) a common sight. The snowy egret, once hunted almost to extinction, is less common, but keep your eyes open for them. On occasion, a common egret will take a stroll down Park Avenue, high stepping in slow motion, looking very uncommon indeed. (Courtesy of the Florida State Archives.)

Capt. Walt Meloon long ago departed on his final voyage, but the Winter Park Scenic Boat Tour just keeps motoring along. Since 1937, it has served more than a million visitors. It has survived droughts, during which the canals were too shallow to navigate, and in 2004, it made it through three hurricanes. Except in the case of any other unexpected acts of nature, you'll find the boats running 364 days a year—every day except Christmas.

Winter Park Mall Shopping Center, Winter Park, Florida

The Winter Park Mall was opened in 1964 and advertised as "a wonderful new world of shopping enjoyment in the southeast's largest totally enclosed air-conditioned Mall." It was a success, but by the 1990s, its world was looking less wonderful. It was redeveloped in 1999 as Winter Park Village. Nothing, however, will ever replace those towers.

Too tired to walk along Park Avenue the six-tenths of a mile from Fairbanks to Swoope? Hop on board "The Villager," an idea whose time has come and gone and come and gone again. This version of quaint public transport on Park Avenue (tried several times before and since) is shown on a 1968 postcard in which the sender writes, "This is what I drive, 6 days a week 10 to 4 PM." Since it is postmarked in August, she must have had a long, hot summer.

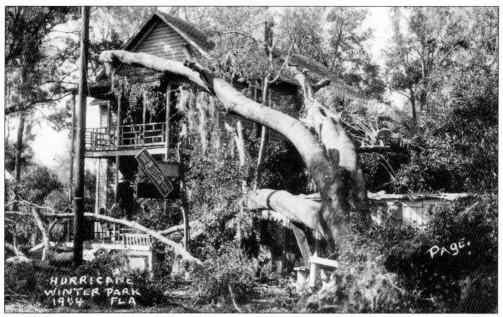

Since Winter Park sits smack in the middle of Florida, which itself is smack in the middle of an ocean and a gulf, the odd hurricane will whoosh through. In 1944, the October hurricane did extensive damage,[6] as shown on these two vintage postcards. This was before the naming of hurricanes, so the storm is known simply by the month and the year that it struck. (Courtesy of Rollins College.)

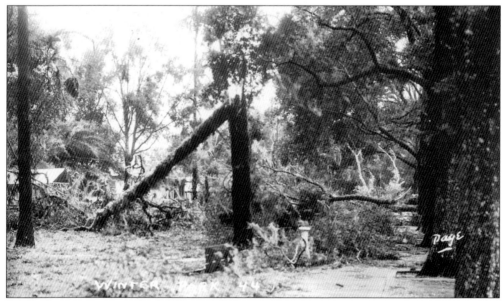

The 1944 hurricane knocked out Winter Park's telephone and electrical system and cancelled classes at Rollins. Not until the summer of 2004—when Winter Park was hit with three hurricanes in a six-week period—would the city face the kind of damage you can see in these postcards. Hurricane Donna did roll through in 1960, but she brought with her mostly heavy rain to Central Florida. (Courtesy of Rollins College.)

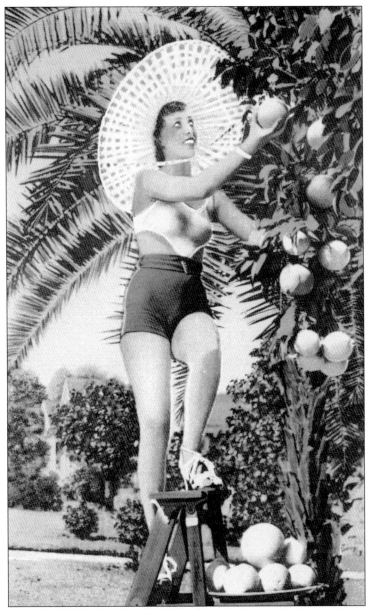

Citrus is still a big business in Florida, but you'll no longer find any commercial groves in Winter Park. There was a great recovery from the freezes of the late 19th century, but new freezes in the 20th century taught growers that Central Florida was just far enough north to face cold weather at regular intervals, and many growers began to move south. Real estate prices in the 20th century made land more valuable for homes than for oranges—in the city of Winter Park, at least—and grove land gradually gave way to development. Counties in Central Florida still produce nearly one quarter of Florida's annual citrus crop, but Orange County (in which you'll find Winter Park) is less orange than it used to be, producing just one percent of the total.[7] There remain a number of excellent citrus trees inside the city, but most are the remnants of the old groves and are now almost entirely on residential property. (Courtesy of the Florida State Archives.)

Whatever happened to Winter Park? You don't have to be a chess whiz to figure that out. The city has continued to thrive and grow within the framework created by its designers. Its 25,000 residents come from all walks of life, and its neighborhoods include bungalows, ramblers, apartments, college dorms, condominiums, duplexes, triplexes, townhouses, small historic homes, modest modern cubes, and, it is true, the occasional mansion. And, since mansions—known then as cottages—were what got Winter Park launched, who is to begrudge them? You can still get together with your friends in Central Park, as these chaps did 70 years ago. The shops come and go on Park Avenue, yet it remains the lively place it has always been. It's a place where locals stop to run errands, grab a sandwich, and chat with friends and neighbors. Our vintage postcards have only taken us across the surface of this city. To know what really happened to Winter Park, you'll have to come and see it for yourself.

ENDNOTES

Introduction
1. The St. Johns River flows from the south to the north, like the Nile, so boats coming from Sanford into Florida's interior actually travel up the river.
2. The Winter Park Company, *Winter Park, Florida 1888*, 2.

Chapter 1
1. Claire Leavitt MacDowell, *Chronological History of Winter Park*, 55.
2. Ibid., 22.
3. Ibid., 71.
4. The Winter Park Company, *Winter Park, Florida 1888*, 8.
5. Claire Leavitt MacDowell, *Chronological History of Winter Park Florida*, 26.
6. David Leon Chandler, *Henry Flagler: The Astonishing Life and Times of the Visionary Robber Baron who Founded Florida*, 98–99.
7. The Winter Park Company, *Winter Park, Florida 1888*, 7.
8. Claire Leavitt MacDowell, *Chronological History of Winter Park*, 79.
9. W. F. Blackman, *History of Orange County Florida*, 172.

Chapter 2
1. Jack C. Lane, *Rollins College: A Pictorial History*, 14.
2. Claire Leavitt MacDowell, *Chronological History of Winter Park Florida*, 32.
3. W. F. Blackman, *History of Orange County Florida*, 173.
4. Claire Leavitt MacDowell, *Chronological History of Winter Park Florida*, 50
5. Ibid., 30.
6. Donald A. Cheney, "The Dinky," *Rollins Alumni Record* (October 1967): 14-15.
7. Claire Leavitt MacDowell, *Chronological History of Winter Park Florida*, 79.
8. Ibid., 87.

Chapter 3
1. Claire Leavitt MacDowell, *Chronological History of Winter Park*, 107.
2. Ibid., 130.
3. Ibid., 136
4. Ibid., 82.
5. Ibid., 122.

Chapter 4
1. W. F. Blackman, *History of Orange County Florida*, 183.
2. Patrick W. and Debra A. McClane, *The Architecture of James Gamble Rogers II in Winter Park, Florida*, 83–84.
3. Claire Leavitt MacDowell, *Chronological History of Winter Park*, 146.

Chapter 5
1. Jack C. Lane, *Rollins College: A Pictorial History*, 53.
2. Ibid., 53.
3. Ibid., 54.
4. Claire Leavitt MacDowell, *Chronological History of Winter Park Florida*, 160.

5. Judith Beale, "A Piece of Old England," *It's About Time: Reflections from Central Florida*, 1, no.2 (2003): 6-7.
6. Wenxian Zhang, *Walk of Fame: A Rollins Legacy*, 7.
7. Ibid., 9.

Chapter 6
1. Claire Leavitt MacDowell, *Chronological History of Winter Park, Florida*, 70.
2. Ibid., 134.
3. Ibid., 159.
4. Ibid., 155.
5. Ibid., 161-162.
6. John M. Williams and Iver W. Duedall, *Florida Hurricanes and Tropical Storms 1871-2001*, 15 & 88.
7. Claire Leavitt MacDowell, *Chronological History of Winter Park, Florida*, 167.
8. Ibid., 231.
9. Patrick W. and Debra A. McClane, *The Architecture of James Gamble Rogers II in Winter Park, Florida*, 38.

Chapter 7
1. Jack C. Lane, *Rollins College: A Pictorial History*, 108.
2. Robin Chapman, *The Absolutely Essential Guide to Winter Park*, 27.
3. Ibid., 23.
4. Ibid., 29.
5. The Winter Park Public Library, digitized history collections online, s.v. "Villa Nova Restaurant" (accessed March 2005).
6. Claire Leavitt MacDowell, *Chronological History of Winter Park, Florida*, 267.
7. Robin Chapman, *The Absolutely Essential Guide to Orlando*, 34-35.

Bibliography

Blackman, William Fremont. *History of Orange County Florida*. DeLand, FL: Painter Printing Company, 1927.

Beale, Judith. "A Piece of Olde England?" *It's About Time: Reflections from Central Florida*. 1, no.2 (2003): 6-7.

Cable, Mary. *Top Drawer: American High Society from the Gilded Age to the Roaring Twenties*. New York: Atheneum, 1984.

Chandler, David Leon. *Henry Flagler: The Astonishing Life and Times of the Visionary Robber Baron Who Founded Florida*. New York: Macmillan Publishing Company, 1986.

Chapman, Robin. *The Absolutely Essential Guide to Winter Park: The Village in the Heart of Central Florida*. Winter Park, FL: The Absolutely Essential Company, 2001.

Chapman, Robin. *The Absolutely Essential Guide to Orlando: Where the World Goes on Vacation*. Winter Park, FL: The Absolutely Essential Company, 2003.

Cheney, Donald A. "The Dinky," *Rollins Alumni Record* (October 1967): 14-15.

Davis, Bobby. *The Knowles Memorial Chapel and its Great Organ*. Winter Park, FL: Rollins College, 2002.

Lane, Jack C. *Rollins College: A Pictorial History*. Tallahassee, FL: Rollins College, 1980.

McClane, Patrick W., and Debra A. McClane. *The Architecture of James Gamble Rogers II in Winter Park, Florida*. Gainesville, FL: University Press of Florida, 2004.

MacDowell, Claire Leavitt. *Chronological History of Winter Park, Florida*. Orlando, FL: Orange Press, 1950.

Parnell, Susana S., and Yvonne C.T. Vassel. *From Miss Lamson's Porch: A History of the Winter Park Public Library*. Winter Park, FL: Friends of the Winter Park Public Library, 1985.

Williams, John M. and Iver W. Duedall. *Florida Hurricanes and Tropical Storms 1871-2001*. Gainesville, FL: University Press of Florida, 2002.

Winn, Ed. *The Early History of the St. Johns River*. Maitland, FL: Winn's Books & Triangle Reprographics, Revision 2, 2001.

Winter Park Company. *Winter Park, Florida 1888*. Boston: Rand Avery Company, Printers, 1888. (Reprinted by Rollins College for the Rollins centennial celebration.)

The Winter Park Public Library, digitized history collections online, s.v. "Villa Nova Restaurant" (accessed March 2005).

Wenxian, Zhang. *Walk of Fame: A Rollins Legacy*. Winter Park, FL: Olin Library, Rollins College, 2003.

Zoller, Ernest, "Requiem for the Dinky." Paper presented to the Winter Park Historical Society, Inc., Winter Park, Florida, 1976.

ABOUT THE AUTHOR

Robin Chapman is a former television journalist who worked in Washington, D.C., and San Francisco, before coming to Winter Park in 1989 to work as a reporter and anchor at Orlando's local NBC-TV affiliate. A native of Los Altos, California, she holds a bachelor of arts degree from the University of California at Santa Barbara and a master's degree from U.C.L.A. She now lives in a historic home in Winter Park's Virginia Heights neighborhood. This is her third book.